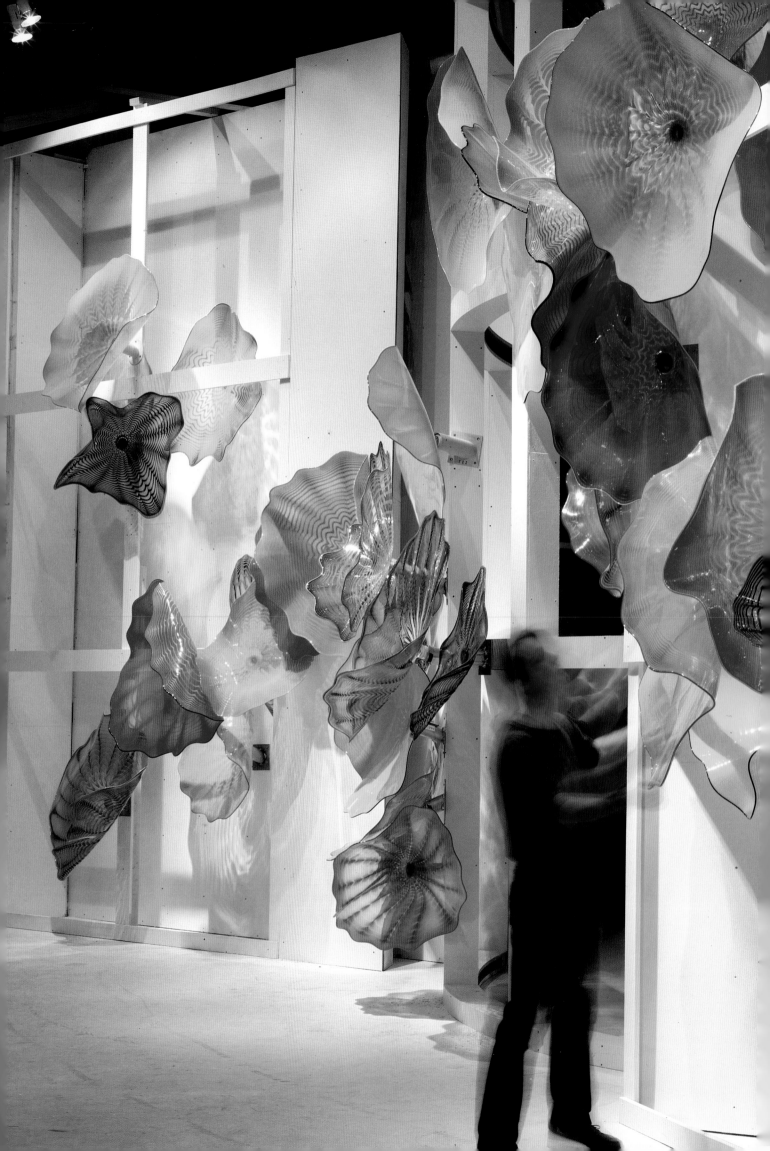

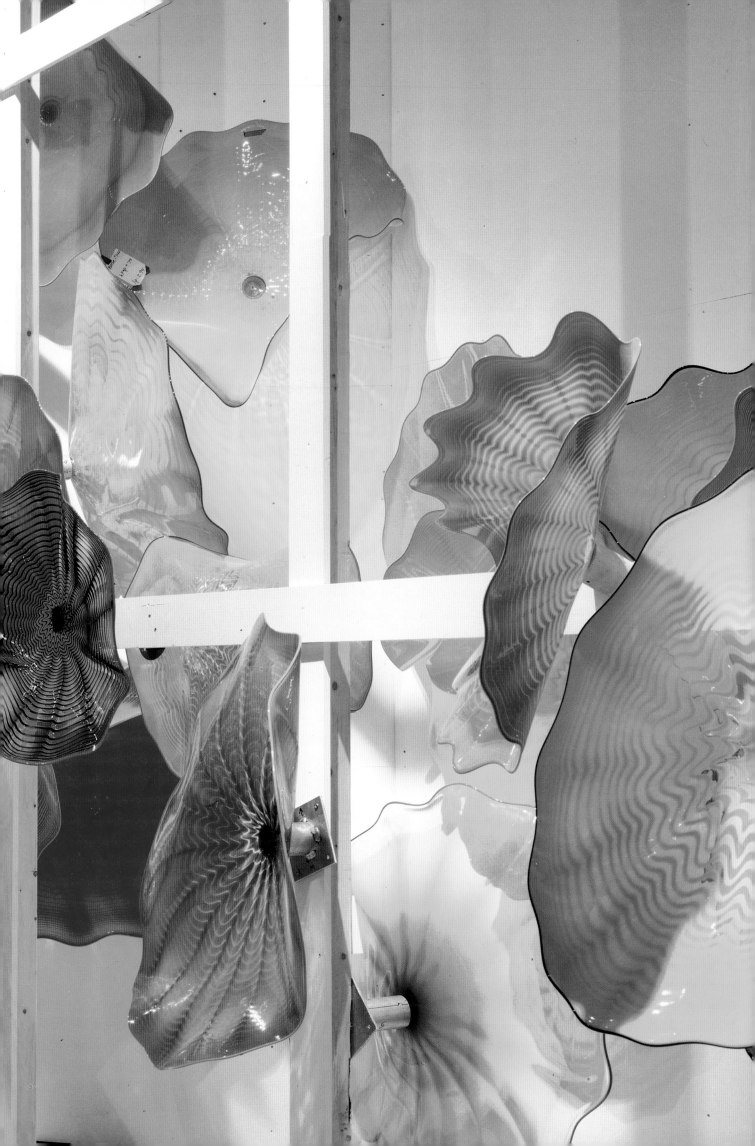

Copyright © Seattle Art Museum 1992
All rights reserved.
ISBN 0-932216-41-2
LC 92-060825

Publication coordinated by Helen Abbott
Designed by Katy Homans
Second printing, printed and bound in Hong Kong
Distributed by the University of Washington Press

Cover:
front, *20,000 Pounds of Ice*, 1992; flap, detail, *Glass Flowers*, 1991; back, detail of a mock-up for the set of *Pélleas et Mélisande*, 1992; flap, *Glass Forest*, 1971–72

Page 1:
Seattle Art Museum Drawing, 1992
Pages 2–3:
Venturi Window for the Seattle Art Museum (mock-up), 1992

Photo credits:
Dick Busher: p. 64/65
Eduardo Calderon: p.57, 58, 60/61, 62, 63
Susan Dirk: p. 14 (lower)
Claire Garoutte: back cover, front flap, p. 1, 2/3, 15, 16/17, 18, 67, 69, 70, 71
Nick Gunderson: p. 6
Kate Elliott: p. 52, 53
George Erml: p. 66
Art Hupy: p. 47
Russell Johnson: front cover, p. 8, 13, 14 (upper)
Seaver Leslie: p. 20, 52
Benjamin Moore: p. 10/11
Paul Parkman: p. 72
Morgan Rockhill: back flap, p. 30, 31, 39, 42, 43, 44
Roger Schreiber: p. 12 (center)
Buster Simpson: p. 40/41
Ray Charles White: p. 59
Photo on page 50 is courtesy of Marvin Lipofsky,
photo on page 55 is courtesy of Bob Duffey,
Saint Louis Post Dispatch.

Dale Chihuly:

Installations
1964 – 1992

Patterson Sims

Seattle Art Museum

1992

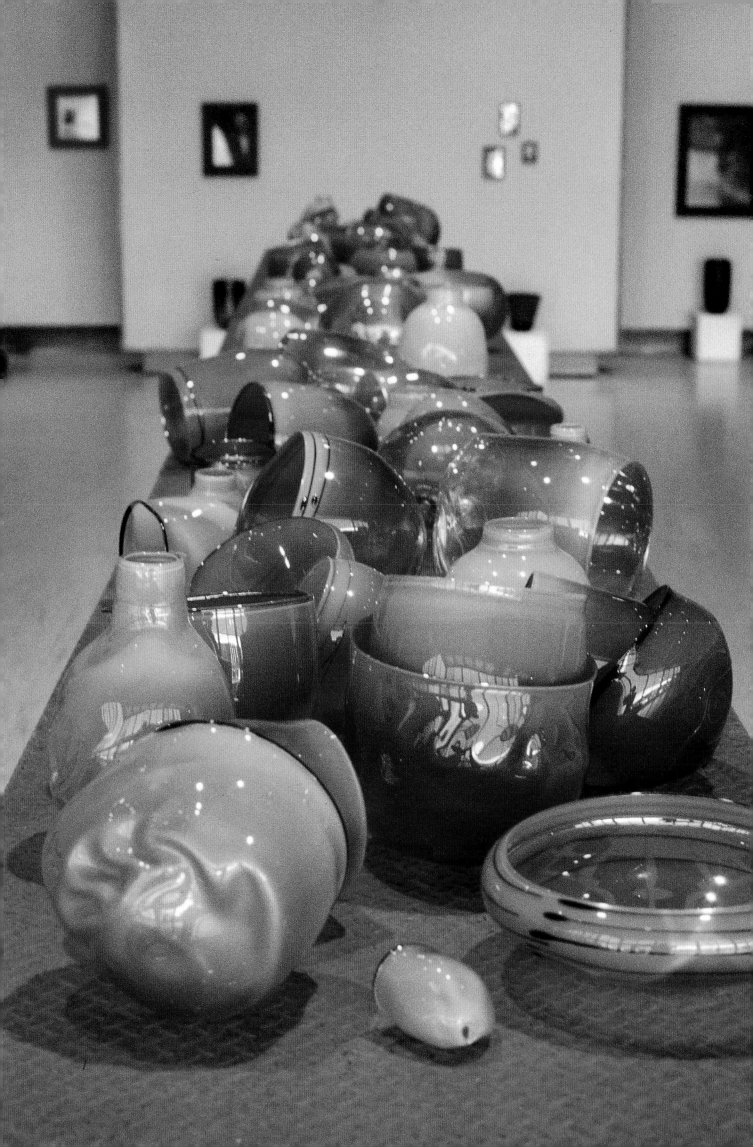

Introduction

Jay Gates
The Illsley Ball Nordstrom Director

Patterson Sims
Curator of the Exhibition
Curator of Modern Art and
Associate Director for Art and Exhibitions

This survey exhibition addresses many aspects of Dale Chihuly's work over the last twenty-five years, but it is not a retrospective. For the first one-artist exhibition in the new downtown Seattle Art Museum building, Chihuly was invited to create a series of installations. *Dale Chihuly: Installations 1964–1992* documents and highlights in the most comprehensive manner to date the development of his art, from his weaving with glass to his design-in-progress of the set for Seattle Opera's presentation of Debussy's *Pélleas et Mélisande.*

This exhibition celebrates the talents of an internationally known artist who was born and reared in Tacoma, Washington, and has been based in the Seattle area for much of his life. It follows long after a 1977 three-artist exhibition at the Seattle Art Museum of his work with his friends James Carpenter and Italo Scanga and reflects the museum's more recent commitment to collect his work in greater depth.

Dale Chihuly's full participation was required for this project, and he was involved in all aspects of its development and realization. As Chihuly is the first to acknowledge, his art would not be possible without the help of collaborators, starting with James Carpenter, and the many gaffers and assistants who, since the early 1970s, have helped him make his art. Carpenter, Roger DesRosier, Seaver Leslie, Richmond Kent, Benjamin Moore, and Bob Reed provided key information about the early installations, and John Hauberg, Marge Levy, Sissy Thomas, and others provided clarifications about the manuscript. Diana L. Johnson and Barry Rosen gave invaluable editorial advice. Chihuly's associate John Landon was involved in the exhibition's mock-up and installation at the museum. Roger Legrano and Charles Parriott worked on the neon and ice installation. Martin Blank, Brian Brenno, Pat Davidson, Paul DeSomma, Evan Farley, Josiah McElheny, Robbie Miller, Joe Rossano, Richard Royal, and Bryan Rubino helped create new work for the exhibition. The artist's main photographers were Claire Garoutte and Russell Johnson. Important assistance for other phases of the catalogue and exhibition came from Laura Brunsman, Kate Elliott, and Tracy Savage, as well as Chihuly's entire studio and office support staff.

The understanding about the special nature of such an ambitious installation evinced by the Seattle Art Museum's registrars and art preparators and installers is noted with thanks, as is the dedication of Karen Ziegler of the Public Relations Department and Helen Abbott, Media and Publications manager. Elizabeth Spitzer, Stokley Towles, and Emily Wolfe of the Curatorial Division provided key assistance. Claudia Hanlon oversaw the educational programs. Rod Reinhardt and Ben Beadles of the Development Division helped secure support for the exhibition.

The early financial contribution for this project by the SAFECO Insurance Companies, long known for its art program, collection of the work of Northwest glass artists, and philanthropic commitment to the Seattle area, made it possible. Financial assistance for this project was also provided by Simpson Paper and the Artfair/Seattle 1992 opening night benefit, which raised money to support the presentation of contemporary art at the museum. Additional funding for Seattle Art Museum exhibitions and education programs is provided by donors to the Annual Fund. Funding for a film on Chihuly prepared in conjunction with the exhibition was generously supplied by Jon and Mary Shirley.

Chihuly installation
Carpenter, Chihuly,
and Scanga, 1977,
Seattle Art Museum
Pavilion, Seattle,
Washington

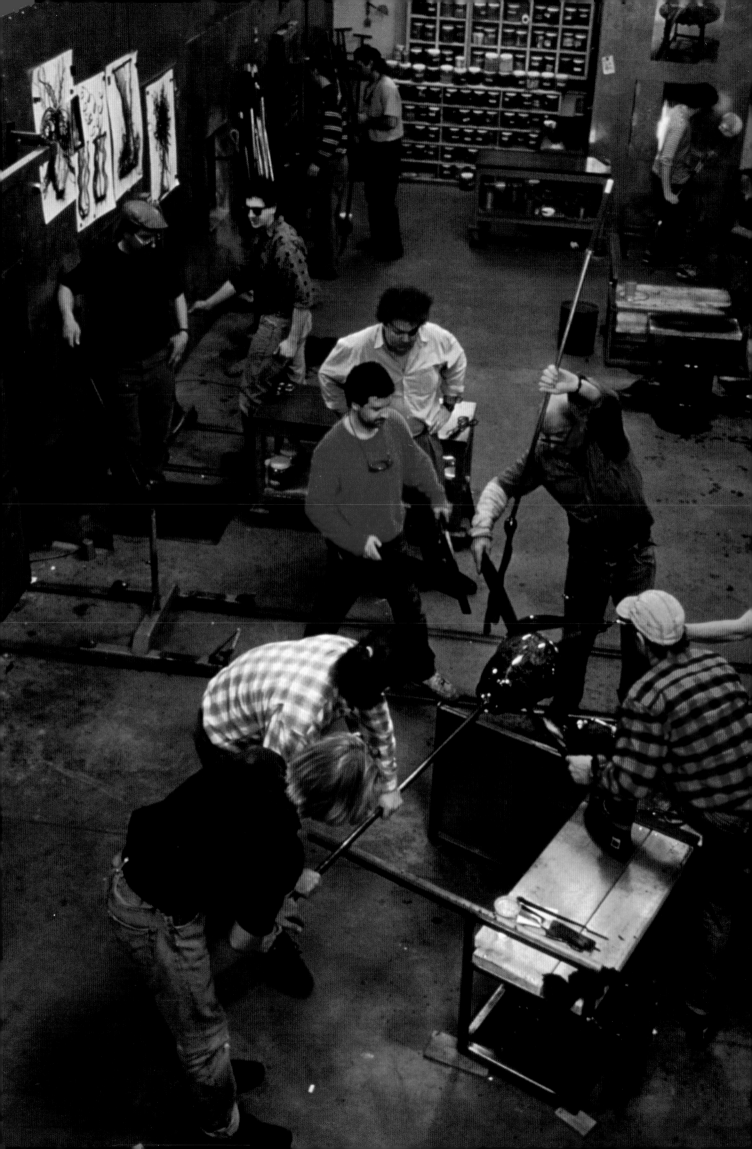

Scuola di Chihuly: Venezia and Seattle

Patterson Sims

Two cities, Seattle, Washington, and Venice, Italy best exemplify the personal and artistic character of Dale Chihuly. They represent the polar opposites of his complex and energetic spirit: love of nature and concentration on basic necessities on the one hand and exoticism and extravagance on the other, an emphasis on normalcy and dedication to work as opposed to escapism and *luxe* style, and a firm grounding in the present versus an infatuation with past splendors. The pairing of these places in his life suggests the contradictory and unfathomable nature of Chihuly and his art. Chihuly and the numerous artists working with glass who have moved to Seattle in the past twenty years have made this Northwest Coast city, like Venice, a world center for the creation of art made of glass.

Chihuly was born in 1941 in Tacoma, Washington, and spent his youth there. He first lived in nearby Seattle from 1960 to 1965, during and just after his student years at the University of Washington. He returned here to live and work in 1982, and since that time, he has become one of Seattle's most fervent devotees, one of its best publicized characters, and the personification of the benefits of the city's much-touted livability and economic viability. Yet Chihuly admits that Venice is his favorite city on earth, cherishing its food, exotic architecture, and idiosyncratic urbanity. During his third visit to this fabled city, he studied glassblowing at the Venini factory on the neighboring island of Murano, and the city's unabashed love of luxury and the genius of its glass artists continue to draw him to Venice and its lagoon.

Seven hundred years ago the Venetian glass industry moved from the city to Murano, where the risk of fire could be contained. Murano's main thoroughfare, with its own *piccolo* canal, is lined on its wider side with seemingly identical shops selling seemingly identical products of the island's numerous glass workshops. The resolute commercialism and tourism on this picturesque street fade as one considers the centuries of artistic genius and technical skill that have dominated this small corner of the world. It was here, in 1968, at the Venini Fabrica, that Chihuly first seriously encountered a form of glassblowing that would ultimately redefine his craft and initiated a creative journey that revolutionized the American as well as the international studio-glass movement. His artistic achievements, supported by his incessant technical innovations, have moved art glass from craft to sculpture.

Before his Venini residency, Chihuly's studies in Madison during 1966 with Harvey Littleton's pioneer graduate program in glass at the University of Wisconsin provided him with a sense of the history of the medium, his first friends who were artists, and some basic skills in glassmaking, but the elaborations—which for Chihuly are the essentials—remained to be learned. After a successful solo exhibition at the university, he received a special one-year degree and then moved to Providence, Rhode Island, to undertake a second graduate degree at the Rhode Island School of Design (RISD). At RISD Chihuly grouped the long-necked, biomorphic forms that had already garnered him prizes in Wisconsin state art competitions into installations and was once again lauded for his innovative work. Although RISD was not yet a center for glass art, Chihuly was invited to teach in the sculpture program there upon his graduation. However, he realized that the mastery of glassblowing in Venice was a necessary prelude to a major teaching assignment. Chihuly wrote to all the leading glass factories in Italy. Only Venini responded. He received a Fulbright Fellowship and a grant from the Tiffany Foundation to support his residency at Venini.

Team at work,
The Boathouse hot
shop, 1991,
(clockwise from
top) Dan Spitzer,
Brian Brenno,
Chihuly,
Bryan Rubino,
Lino Tagliapietra,
Benjamin Moore,
Janusz Pozniak,
Robbie Miller,
Lark Dalton,
Martin Blank

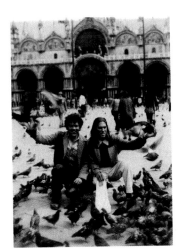

Chihuly and
James Carpenter,
1972, Piazza di San
Marco, Venice,
Italy

Chihuly was both the first American glass artist to study officially at the Venini Fabrica and the first recipient of a Fulbright Fellowship for the study of glass. Thomas Stearns, an American fiber artist, had done some work at Venini as early as 1960 and, following Chihuly, studio-glass artists Richard Marquis, James Carpenter (with Chihuly), and others came to make glass at Venini. They were warmly welcomed in keeping with the factory's emphasis on collaborative work, a practice which has benefited numerous artists and, even more frequently, architects.

Although Chihuly had made brief trips to Venice in the early 1960s, he considers his Fulbright residency in 1968 to be the first meaningful visit. He arrived in September of that year and was quickly ensnared by the spell of Venice, and by December he was ready to start his work at Venini. On his first day there, he met Venini's director, Ludovico de Santillana, who was very comfortable with Americans, and he came to treat Chihuly almost like a son. Because of Chihuly's background in design and architecture, Santillana assigned him to work on an important sculpture competition for the city of Ferrara. This project, combining glass, plastic, and neon, consumed most of Chihuly's time at the factory, but was never realized. Though he lacked the skills to blow glass with the Muranese team, he watched from the sidelines, absorbing techniques that had long been secret and were essentially unknown in the United States. As Italy's most progressive glassworks, Venini, then as now, coupled high style with elegant function. The factory had revived traditional Venetian decorative techniques, while refining the vessel and other functional and sculptural forms. Behind its austere, closed facade, it produced glass that was contemporary in style yet traditional in spirit, aimed at a clientele of art collectors, rather than tourists.

Perhaps the most critical lesson Chihuly learned at Venini was the centrality of the team to successful glassblowing. The sheer physical demands of the process require skilled collaborators. Even if at certain of the Murano factories glassblowing became a spectator sport for tourists, this is not the approach taken within the exclusive confines of Venini. Though the general Muranese model might be assumed as the origins of Chihuly's later road-trip demonstrations and crowd-pleasing glassblowing sessions, they arise more from Chihuly's instructive instincts and gregarious personality. Murano's typical alliance of production and sale, the bottom line of Venice's commingling of trade and culture, is offensive to Chihuly. Venini remained above the theater/marketplace of the rest of much of Murano. Chihuly spent nine months in Venice, and it was this experience that gave Chihuly the student the vision of what he might become as Chihuly the master.

In the summer of 1969 Chihuly returned to the United States and taught classes at the Haystack Mountain School on Deer Isle, Maine. In the fall, he went back to RISD to start a glassmaking department that would leave an imprint not only on the school, but on the entire American glass movement. However, it was another summer school, started in 1971, that played a critical role in Chihuly's reconnection to the Northwest and the development of glassmaking in the area. With an initial grant of two thousand dollars from the Union of Independent Colleges of Art (UICA) and the support of the Seattle art collectors Anne Gould Hauberg and John Hauberg, the Pilchuck Glass School was established. To an idyllic spot, in the middle of John Hauberg's experimental tree farm north of Seattle, Chihuly and his RISD colleagues James Carpenter and John Landon

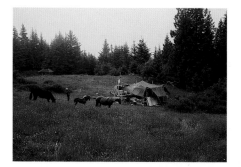

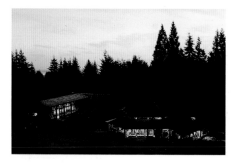

Pilchuck Glass
School hotshop,
Stanwood, Washing-
ton, 1971 and 1987

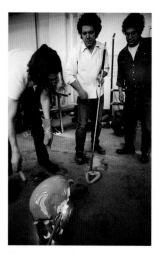

Chihuly, Italo
Scanga, James
Carpenter,
April 1971,
RISD glass shop

brought a small band of UICA students and a few faculty members. Through a blend of idealism, camaraderie, and manic energy and with the Haubergs' blessings and resources, what was originally nicknamed the Peanut Farm became the Pilchuck Glass School, for the tree farm on which it was sited. (Pilchuck means "red water" in the jargon of the native Chunuck language and refers to iron deposits in the water.) As Pilchuck Glass School's first director, Chihuly, not yet thirty, shaped its philosophy and curriculum. Taking the best from each of his experiences at the University of Wisconsin, RISD, the Venini factory, and Haystack, he made the master-and-team approach the basis of Pilchuck's teaching.

Chihuly has been actively involved with the school ever since. Pilchuck, now with a momentum of its own, has grown to have a 1992 budget of 1.2 million dollars, a summer program of two hundred fifty students and fifty teaching assistants, thirty faculty members, ten artists-in-residence, and ten gaffers (master glassblowers). A cadre of artists works at its campus throughout the year.

The establishment of the Pilchuck Glass School in 1971 was a natural evolution for Chihuly. Although he continued to teach at RISD until 1982, Pilchuck provided him the opportunity to develop his own ideas about glassmaking and return to his birthplace in the Northwest for professional as well as personal reasons. Having lost his father and only sibling (a brother) when he was in his mid-teens, he regularly returned to the area from RISD to visit his mother in Tacoma. When he eventually settled in Seattle in 1982, he was able to point out that the city was equidistant from Tacoma and Pilchuck.

Chihuly has always been a frequent flyer in both the literal and the figurative sense. Together with teams that centered on a group of artists, including Kate Elliott, Benjamin Moore, Bill Morris, Flora Mace, Joey Kirkpatrick, Rich Royal and, most recently, Martin Blank, Chihuly has shared the excitement of producing an impressive body of work at art schools, universities, and glass factories. Quickly sensing people's gifts, Chihuly collects new and promising young artists during these visits, but Pilchuck remains the most fertile ground for new talent. Drawn by the esprit de corps, many of Chihuly's best associates move to Seattle or, like many Pilchuck veterans, remain in the area when classes are over. Like others, they settle in Seattle for the opportunities, the natural beauty, and the tolerance of independent thinking.

While the move to Seattle made sense for Chihuly personally, it was a less obvious choice from a professional point of view. The Seattle art scene of the 1970s was modest, at best. With the lively exception of the Seattle World's Fair in 1962, contemporary art was only infrequently "imported" from outside the area. In 1975, the Seattle Art Museum (with its concentrations in Asian and contemporary Northwest art) established a Department of Modern Art under the leadership of Charles Cowles, who had come from *Artforum* magazine in New York. The sophistication of his ideas and those of art historian and curator Jan van der Marck at the University of Washington began to open up the local scene. When two years later, Chihuly, James Carpenter, and Italo Scanga were shown together at the museum, it was its first expression of interest in glass and the Pilchuck Glass School. Cowles, and others, swiftly acknowledged that glass was a medium not to be confined to the arena of craft, vessel form, or decorative arts; that it could be a medium of sculpture; that art need not be defined and limited by medium.

**Team at lunch,
The Boathouse,
1991**

Chihuly had made the decision by 1980 to give up full-time teaching and his position as head of the Glass Department at RISD, so the move to Seattle in 1982 was by no means an abrupt transition. Perhaps the ultimate break came when he sold his beloved water-side residence in Providence, which, like his current studio in Seattle, was called "The Boathouse." By the time of the move, Chihuly's artistic success was indisputable, and his talent and personality quickly put him at the absolute, if unstated, center of the community of Seattle glass artists. He established his first Seattle studio, the Buffalo Building, in 1986, and in 1987 a hot shop in a nearby space at the south end of Lake Union. Until that time, he used the glassmaking facilities at Pilchuck or his friend Benjamin Moore's King Street studio. With his purchase and transformation of the Pocock factory building in 1990 at the north end of Lake Union, the second "Boat-house," Chihuly added the most technically advanced glass studio to Seattle's more than thirty-five hot shops built since the establishment of Pilchuck. In fact, Seattle is second only to Venice in its concentration of artists and artisans who work with glass, and many have worked for Chihuly in jobs that range from gaffer to photo-archivist. In addition to its growing fame as a glass center, Seattle is known for its support of public art programs, another area of contemporary art making which, like Chihuly's glass, depends on team-work. Since he received his first commission in 1979, public art has become an increasingly crucial part of his artistic life.

Chihuly himself has become the area's best-known artist, both nationally and interna-tionally, since Mark Tobey, with whom he shares the distinction of an exhibition at the Louvre's Museum of Decorative Arts, the first two U.S. artists so honored. However, he has always acknowledged the importance of teamwork and never fails to give credit to his co-workers. It is also common practice for him to confer with everyone at all times about everything. As one of his friends has pointed out, for Chihuly the best way to get a job done well is to have a few more people around than is absolutely necessary. He credits his leadership skills to his father, who was a labor organizer for the meatcutter's union. But that is only one of the qualities that make people gravitate to Chihuly. To say that he is affable and generous by nature is an understatement. To a remarkable degree, his Seattle studio has become a primary destination for distinguished visitors and philanthropic groups, and he is likely to ask these visitors or even passersby their opinion of an installation, a detail of The Boathouse, or some other preoccupation of the moment. Like Andy Warhol—whom he acknowledges as something of a role model—Chihuly turns all who cross his path into members of "The Factory." He runs the studio as a director might oversee a large cast and crew on location shooting an epic film.

As the maestro of The Boathouse, Chihuly presides over the creation of his art with a gesture here and a few words there. Using drawings as a guide or with just brief conversations and suggestions, his team produces work in fabulous abundance. The series known as *Venetians* are among his most recent works, but despite their appella-tion, they could never have been made in any shop in Venice. Inspired by a group of rare Venetian art deco vases Chihuly first saw in 1987 at a palazzo in Venice and described as "very odd, with garish colors," these extraordinary and flamboyant vessels are his crowning achievement. Their technical wizardry requires the specialized facilities of The Boathouse and teams of up to eighteen.

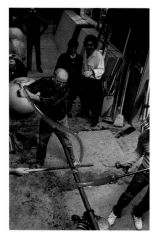

Chihuly with
Lino and Lina
Tagliapietra, The
Boathouse hot
shop, winter 1991

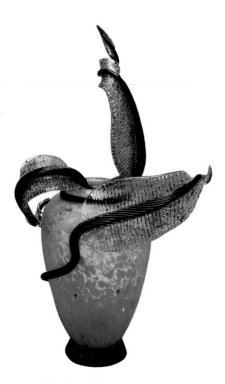

Cadmium Yellow
Venetian #84,
1989, glass,
28 x 19 x 12 in.,
Eugene Fuller
Memorial Collec-
tion and gift of
the Estate of Mark
Tobey by exchange,
Seattle Art
Museum, 90.28

To watch Chihuly and his teams at work is to behold the technical and artistic redefinition of a medium. New methods and possibilities are explored in every session. The no-nonsense crew favors results over grace, excepting the occasional spasm of dance by a surprisingly lithe Chihuly. To the driving beat of rock and roll, working from Chihuly's drawings, the crew takes Chihuly's two dimensions into three. As neutral and professional as if they were assembling a Maserati, Chihuly's crews create the most excessive, most deluxe, most unabashedly decorative and formally challenging works of his career. Looking as if a vase had an affair with a chandelier, Chihuly's *Venetians* would appear to have much more to do with Venetian tourist glass than with the elegant products of the Venini Fabrica. Yet Venini's leaf-shaped plates, handkerchief vessels, and a handful of more ornate vases of the 1920s are the vague precedents for the *Venetians*. From the first *Cylinders* to the recent *Floats,* his glass confounds the distinctions between vessel and sculpture.

For the *Venetians* Chihuly has used great glass masters from renowned factories to assist him, regularly inviting from Venice his friend Lino Tagliapietra and, sometimes for a memorable week or two, the Venetian master of solid glass, Pino Signorreto, masters who bring with them all the secrets of Murano to the process. The *Venetians* are far from staid, symmetrical productions, and Chihuly pushes the Italians to the extremes of their talent, to larger scale, to more exaggerated stylizations. The *Putti,* created with Signorreto, combine mocking self-portraiture with impish kitsch. The precision and delicacy of Tagliapietra's own work is not to be found in the overstated, exquisite vulgarities he makes for Chihuly. There is not much talk during the process: Tagliapietra is learning English, and Chihuly communicates with an Esperanto of gestures and single syllables, along with a constant stream of drawings.

The *Venetians* followed the *Seaform, Macchia,* and *Persian* series—works strikingly prescient of the biomorphic, abstract painting and sculpture of such artists as Terry Winters and John Newman—and are themselves to some degree rococo summations of the U.S. pattern and decoration style of the late 1970s and 1980s. They remain, above all, redolent of Venetian art, particularly in the fat little angels that alight upon flowers, hover over the lip wraps of vessels, or bury themselves in fleshy, vibrantly colored ornament. Marrying the opulence of Venice to American vitality and ingenuity, the *Venetians* are fin-de-siècle outpourings and gold-flecked antidotes to a world immersed in poverty, defeated by decay, and convinced of the end of the *grand luxe* of the 1980s.

The Boathouse is the most perfect of "Muranese factories"—studio, residence, and storehouse rolled into one, while at the same time being the closest that one can come in Seattle to a Grand Canal palazzo. Chihuly has recreated in Seattle his favorite Venetian experience of watching the boats glide by, and his birch bark canoe (the Yankee gondola) is ready at all times to be slipped off the dockside edge of The Boathouse into the Lake Union ship canal.

Chihuly's expanding importance as an artist lies in large part in his consistent ability to pursue stylistic shifts and to push variations and embellishments of prior achievements to unexpected and ever bolder ends. His newest series of *Floats* trades the rococo excesses of the *Venetians* and the *Putti* series for the purity of large blown-glass spheres that look like beach balls for the impressionists. His recent multi-part public installa-

tions are the secular descendants of the vast mural cycles in Venetian palazzos and churches. Awash with light, they suggest not their spiritual and intellectual heights but the formalist verve and flourish of the extravaganzas of the Tiepolo family, Tintoretto, and other Venetian masters. As with the best Venini glass, Chihuly's work renders meaningless the distinctions between utilitarian product and art, art and craft, beauty and function. For twenty years, Chihuly has been the maestro, presiding over a school inspired by Venice and situated in Seattle. The *scuola di* Chihuly—like its leader—is a mobile nexus of creative exuberance.

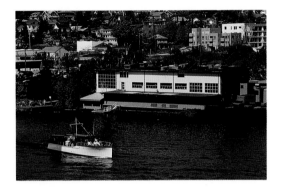

**The Boathouse,
Lake Union Ship
Canal, 1991**

**Overleaf:
The Boathouse,
1991**

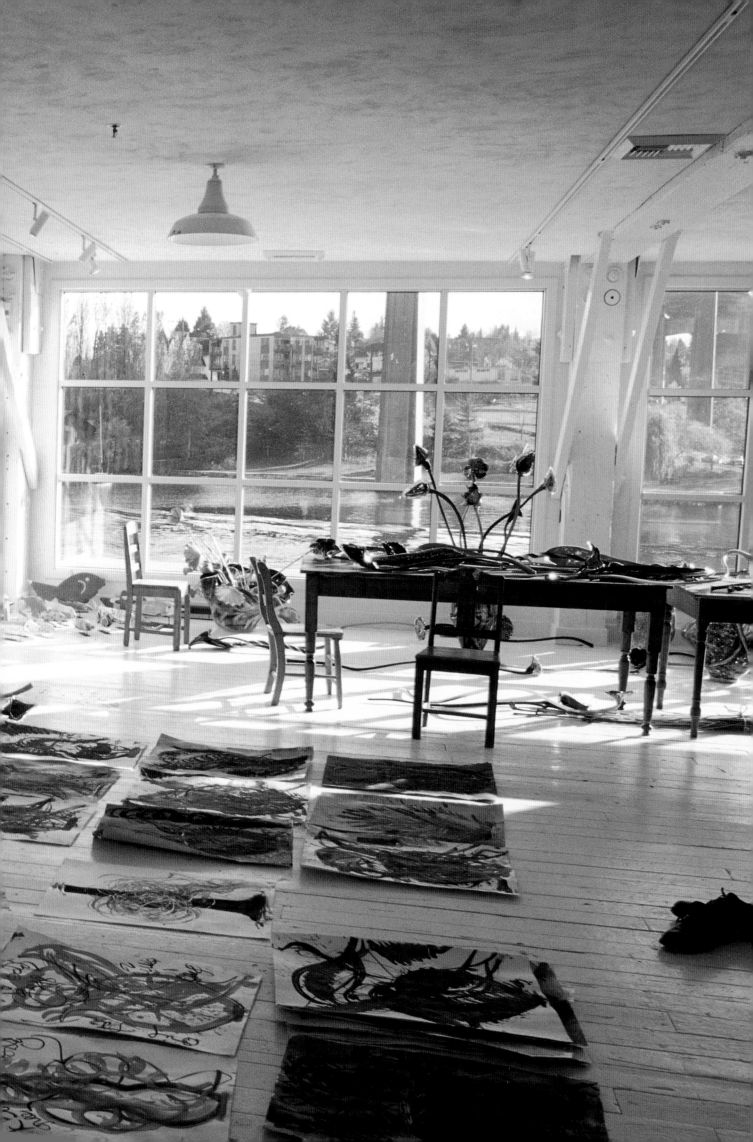

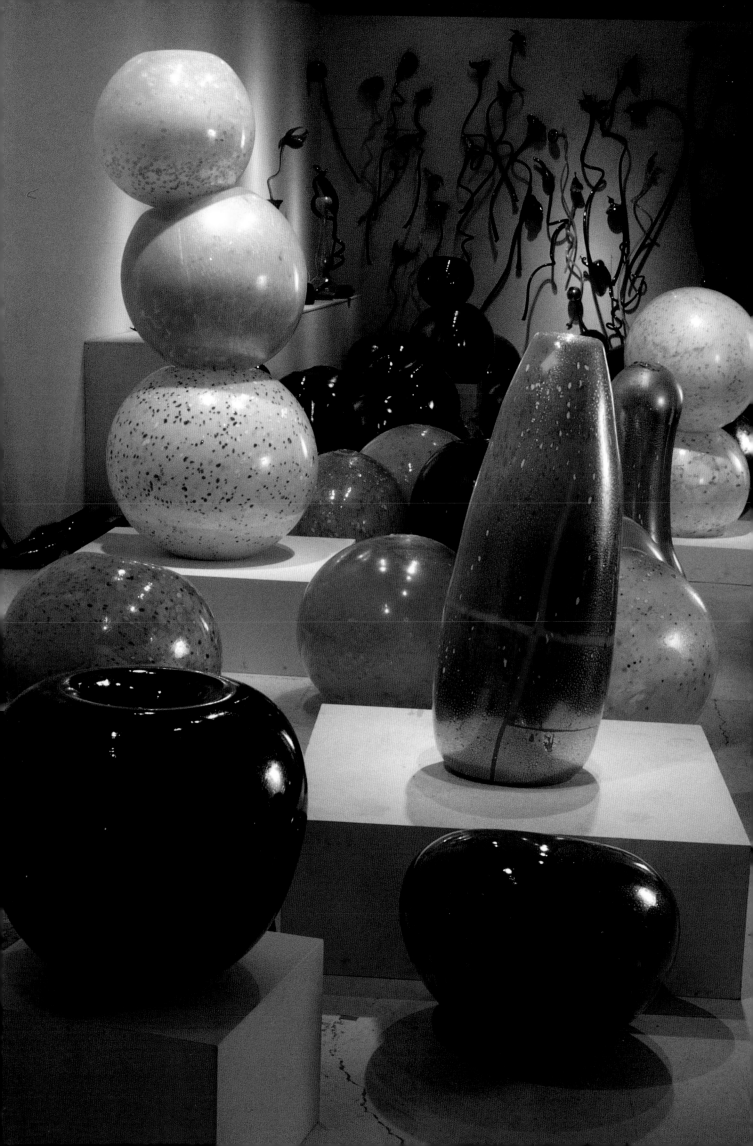

Selected Installations
1964–1992

1964

Weaving with fused glass, Viola Chihuly, Tacoma, Washington

1971–72

Glass Forest #2, Museum Bellerive, Zurich, Switzerland
In collaboration with James Carpenter

1973

Pilchuck Window Sampler No. 3, Crafts Council of Australia, Sydney
In collaboration with James Carpenter

Cast Glass Door, Collection of John H. Hauberg, Seattle, Washington
In collaboration with James Carpenter

1974

Corning Glass Wall, Corning Museum of Glass, Corning, New York
In collaboration with James Carpenter

Pfannebecker Window, Collection of Robert J. Pfannebecker, Lancaster, Pennsylvania
In collaboration with James Carpenter

1978

Bluepoint Doors, Bluepoint Oyster Bar & Restaurant, Providence, Rhode Island

1979

Pilchuck Basket Installation, U.S. Border Station, Blaine, Washington

1980

Shaare Emeth Synagogue Windows, Saint Louis, Missouri

1983

Wintergarden Installation, Sheraton Tacoma Hotel, Washington

1984

Madison Hotel Seaform Set, Stouffer Madison Hotel, Seattle, Washington

Tacoma Financial Center Installation, Washington

1985

Fleet Bank Installation, Fleet National Bank, Providence, Rhode Island

Macchia Installation, Hillhaven Corporation, Tacoma, Washington

1986

Flower Forms #2, Sheraton Seattle Hotel and Towers, Washington

1987

Puget Sound Forms, The Seattle Aquarium, Washington

Rainbow Room Frieze, Rockefeller Center, New York, New York

1987–92

Chihuly Collection, Tacoma Art Museum, Washington

1988

Adelaide Fountain, Hyatt Hotel, Adelaide, Australia

Chancellor Park Persian Installation, Chancellor Park, San Diego, California

Frank Russell Installation, Frank Russell Building, Tacoma, Washington

IBM Macchia, IBM Corporation, New York, New York

Shirley Wall Installation, Jon and Mary Shirley, Bellevue, Washington

1989

Oceanic Grace Installation, S.S. Oceanic Grace, Tokyo, Japan

Persian Installation, Irvin J. Borowsky and Laurie Wagman, Philadelphia, Pennsylvania

Radnor Stairwell, Norman and Suzanne Cohn, Radnor, Pennsylvania

1989–91

Pacific First Persian Installation, Prescott Collection of Pilchuck Glass, Pacific First Centre, Seattle, Washington

1990

Blue and Oxblood Wall Installation, Robins, Kaplan, Miller & Ciresi, Minneapolis, Minnesota

Dobbs Wall, Mr. Leonard Dobbs, Long Island, New York

Milstein Wall, Mr. and Mrs. Paul Milstein, New York, New York

Security Pacific Bank Installation, Los Angeles, California

Tropicana Wall, Tropicana Products, Inc., Bradenton, Florida

1991

GTE Wall, GTE World Headquarters, Dallas, Texas

Hiroyoshi Torii Tea Room, Yasui Konpira-gu Shinto Shrine, Kyoto, Japan

Shulman Wall, Mr. and Mrs. Lawrence Shulman, Chicago, Illinois

1992

Ikebana Installation, Mr. and Mrs. Stuart Cauff, Miami, Florida

Persian Pair Installation, Japan-America Society, UNICO Properties, Inc., Union Square, Seattle, Washington

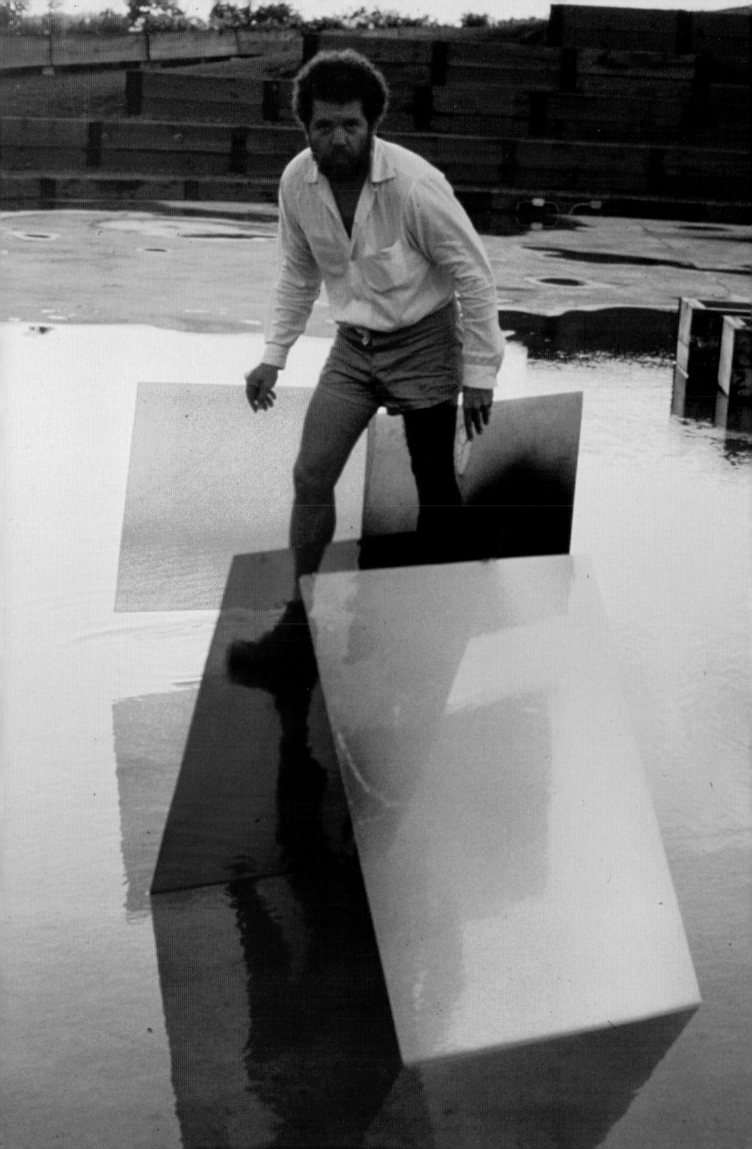

Installations
1964–1992

Glass is the most magical of all materials. It transmits light in a special way, and, at any moment, it might break.

Public installations are my favorite form of art because so many people get to see them. I'm lucky that my work appeals to so many people of all ages. It's more accessible than most public work. A lot of that has to do with the material.

— Dale Chihuly, 1992

It was not until his mid-twenties that Dale Chihuly became fascinated by glassblowing. Since then, through ceaseless experimentation and innovation, he has taken a medium known for everyday functional and decorative objects into the realm of fine art. Chihuly and a few other artists such as Howard Ben Tre, William Morris, and Hank Murta Adams have, during the past twenty years, shepherded the development of technical advances in glassmaking which have permitted changes in scale, color, complexity, and strength unparalleled in the more than two-thousand year history of the medium.

Chihuly has "always been interested in space and architecture." (artist's notes, 1992) As an undergraduate at the University of Washington, he studied architecture and received his degree in interior design. Upon graduation Chihuly was employed as an interior designer, and it is design and spacial arrangement that is his métier.

At his first cabin at Pilchuck made of window frames as well as his current lakeside "Boathouse" studio in Seattle, Chihuly has devoted immense energy and thought to the design of his surroundings. His constant shifting of his own glass and diverse collections of fine and decorative art—currently dominated by fish decoys, birdhouses of mansion scale, carnival chalk-ware figurines, and Pendelton blankets—keeps The Boathouse in a wondrous flux.

From his early *Basket* forms to recent putti-encrusted *Venetians*, Chihuly has created individual works in abundance, but it is his multi-part sets, complex groupings, and ultimately his installations that are his most unforgettable artistic achievements.

Chihuly rendering for interior design, 1965

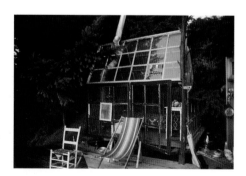

Chihuly's cabin at Pilchuck, 1972

Chihuly at Artpark, 1975, Lewiston, New York

Weaving with Glass
1964–66

Dale Chihuly first used glass in a weaving class at the University of Washington. His teacher Doris Brockway assigned the problem of loom weaving with a non-fiber material, and Chihuly picked glass "because it was the material most foreign to fiber." (Linda Norden, *Dale Chihuly Glass*, p. 7) Chihuly cut flat panes of colored glass into rectangles and incorporated small, often slumped, or fused, bits into panels of open weaving and created several shimmering tapestries. "While discovering ways of incorporating glass into the tapestries, I also developed equipment to melt and fuse the pieces of colored glass together with copper wire, which I could then weave into the fabric. . . . I learned more about the fluid possibilities of the material and soon became immersed in my glasswork." (*Chihuly: Color, Glass and Form*, p. 15)

The largest (48 inches by 66 inches) and most successful of these textile and glass curtains was begun in 1964 as a gift for his mother. This weaving still covers the window in the dining area of Viola Chihuly's Tacoma home. It transforms an ordinary, suburban view into a faceted composition of line and small rectangles of color. The first public showing of Chihuly's work was a single panel exhibited in Bellevue, Washington, at the Art Fair in 1965. This earliest work in glass

recalls for Chihuly that his first memory of the beauty and allure of this material goes back in time to beach walks with his family when he would collect and treasure the smooth, sea-washed pieces of glass.

Graduating from the University of Washington in 1965, Chihuly worked for John Graham Architects, Seattle's biggest firm, best known for its Space Needle for Seattle's 1962 World's Fair. At the firm he helped design several local shopping malls and continued to experiment with weaving colored glass elements. That same year Chihuly received a Fulbright Fellowship to study weaving in Finland, which he had to decline. But by the end of 1966, his fascination with blown glass had overtaken his interest in weaving.

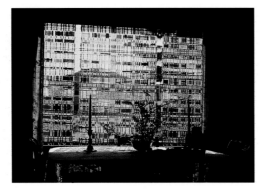

Weaving with fused glass, 1965, 48 x 66 in., Viola Chihuly dining room, Tacoma, Washington

Weaving with fused glass, 1965, Bellevue Art Fair, Washington

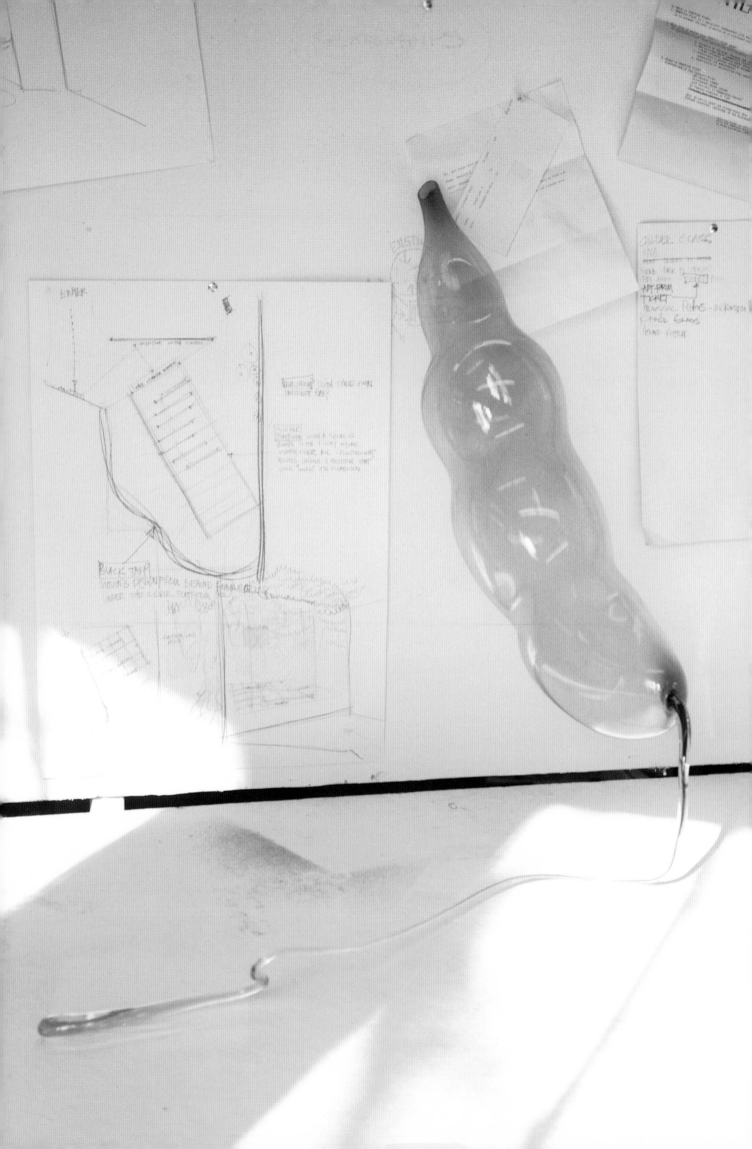

Early Blown Glass 1965–68

During the fall of 1965, Chihuly attained the rudiments of glassblowing while working with bits of melted flat glass in his Seattle basement. He learned that the best glassblowing program in the United States was at the University of Wisconsin in Madison, and upon his acceptance there he left Seattle in September 1966 to study glassblowing with Harvey Littleton, the preeminent U.S. authority. In Littleton's first-of-its-kind graduate program Chihuly swiftly mastered the essentials of glassblowing, gained a basic understanding of the history of glass, and for the first time got to know dedicated artists. The long-necked, organic forms Chihuly blew he grouped into simple installations, and he won awards in several state art competitions that year.

At Wisconsin, and the following summer in Seattle, he mixed glass with other materials and took many liberties with the medium: blowing glass around steel, using commercial neon, and boxing blown glass in clear and tinted Plexiglas containers, reminiscent of the work of California artist Larry Bell, though Chihuly did not know Bell's work. A graduate exhibition in 1966 of his first blown glass earned him a special MFA after just one year.

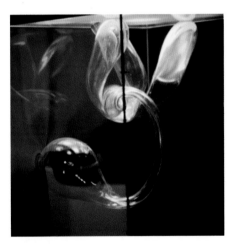

Untitled, 1967, glass, steel, plastic, 6 ft. high

Graduate studio, RISD, 1968

Glass Environments 1967–68

Attracted by the reputation of the Rhode Island School of Design (RISD), Chihuly moved to Providence, Rhode Island, in the fall of 1967 to assume a teaching assistantship. RISD had no glass program, but Chihuly had heard that it had excellent students and he liked its East Coast location. That fall he used the school's little glass furnace to make larger scaled installations and furthered his experimentation with blown forms with what he has described as "blown glass loaves of bread." (conversations with the author, 1992) Drawing on his memories of his teenage employment in a slaughterhouse, he hung glass forms like "slabs of meat from a butcher." At this stage he could blow only clear glass, so he added color with sprayed lacquer paint and by filling the glass with electrified neon. A relationship with a neon supplier enabled him to get neon at a very reasonable price. As Linda Norden notes, "Chihuly has said that his early interest in neon stemmed from a desire to animate the glass, to move from solid, sculptural statements to more energized environments that invited human participation and response." (Norden, p. 9)

Chihuly made an ongoing installation in the basement and sub-basement of his RISD studio (a former funeral home), where he not only worked but clandestinely lived. There he would pour and blow molten glass from a ladder. A combination of brightly lit attenuated and bulbous glass elements had the effect of three-dimensional painting, and Chihuly liked the grimy disarray of the subterranean spaces where he set up the pieces. In one set-up he added foam rubber to the mix of glass parts. The contrast between the shiny new bubbles of glass and the dark interiors gave the works— and the slides he took of them—a visceral power.

Chihuly recalls having "no possessive instinct" (conversations with the author, 1992) about these works. The point was to generate them, fool around with them, light them carefully, look at them, and, when possible, document them. For Chihuly the glass's fragility and the tenuousness of his compositions ultimately made the photographic record the most satisfactory and permanent manifestation of these pieces. This reliance upon photography eventually led him to the contention that the best "Chihulys" are those that photograph best.

His installation works and the focus of his artistic concern during this period might be compared with the free-form, multi-media and process-based installations of other late-1960s U.S. post-minimalists such as Eva Hesse, Richard Serra, Lynda Benglis, Barry Le Va, and Keith Sonnier as well as the *arte povera* movement abroad. Like them, Chihuly made creative use of commonplace, industrial, and ephemeral materials in impromptu and poetic arrangements. Temporary aesthetic impact, not permanence, was their purpose, and like many other works of art of the late 1960s and early 1970s, Chihuly's pieces were created independent of the marketplace and may be tied to the period's political upheaval and anarchism.

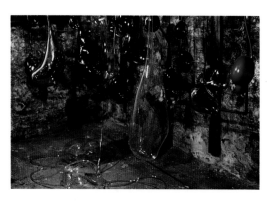

Glass Environment #3, 1968, 200 sq. ft., RISD

Glass Environment #4 (detail), RISD

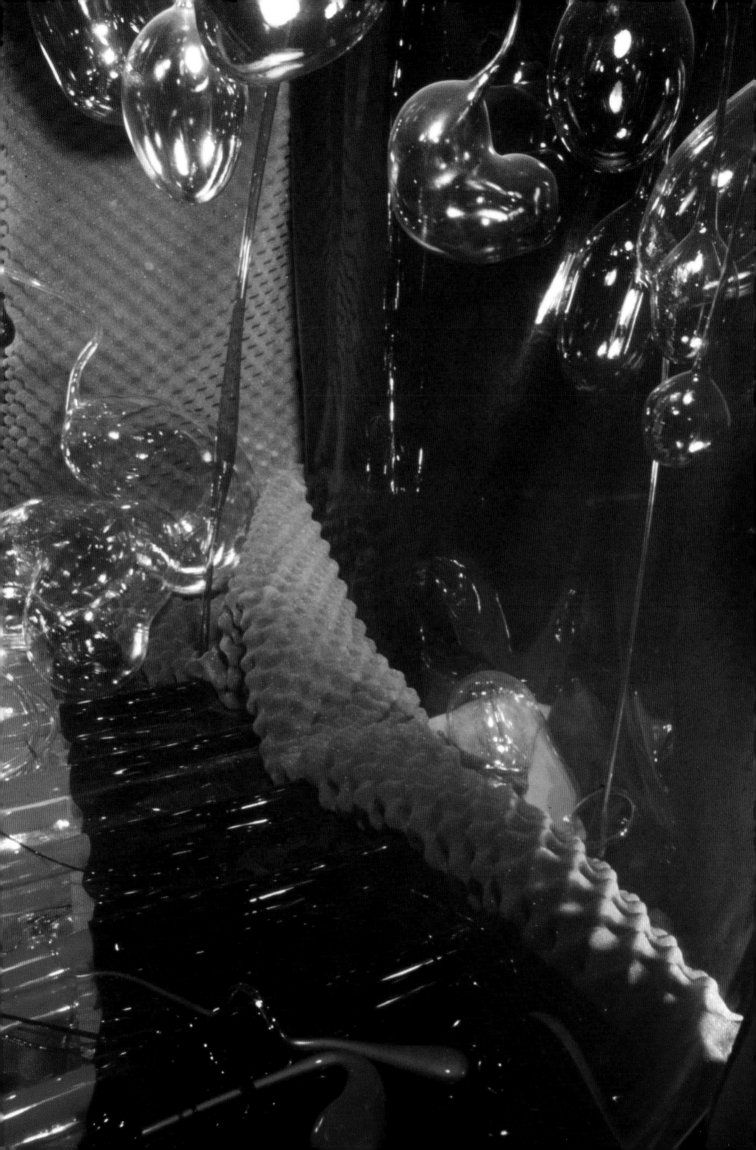

Venini Residency
1968–69

In the fall of 1968, Chihuly interrupted his work at RISD to take advantage of a second Fulbright Fellowship, for travel to Italy and to work at the Venini Fabrica on Murano. He knew that the best glass-blowing in the world was done there, and he wanted access to the techniques that had been refined on the island over the centuries. Though Venini hosted many visiting artists and architects, in the factory individual signature styles were shunned in favor of teamwork and intense technical experimentation. Comparatively deficient in glassblowing skills but with significant architectural and design experience, Chihuly was assigned to work, on his own, on the proposal for an architectural competition in the city of Ferrara. Intended to be walked through, Venini's entry for the lobby installation was to be made of plastic, glass, and steel. Although the installation was never realized, a photograph of its sleek model indicates it was very much of its time: see-through, corporate high-tech. One spherical element of the installation was made in full scale. Outlined with opalescent neon, the sphere was turned into a prototype lighting fixture. No longer extant, this 36-inch fixture was the chief tangible product of Chihuly's months on Murano at Venini Fabrica.

While at Venini, Chihuly was free to study the processes of glassblowing as practiced by a select handful of master glassblowers, together with teams of assistants. He absorbed the collaborative master-and-team approach and has made it his own, although when he returned to Providence in the fall of 1969 to head the new glass program, Chihuly continued to work alone on glass and neon installations.

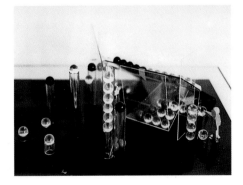

Venini mock-up, Ferarra architectural competition, 1968–69, glass, plastic. Human figure at right denotes scale

Full-scale detail, 1968, glass, plastic, neon, 36 x 18 in.

Neon Installations 1969–71

Returning to RISD in 1969, Chihuly used "amorphic shapes. . . . dripping molten glass out of the furnace." (*Chihuly: Color, Glass and Form*, p. 17) He added color with neon and argon gases and was able to blow colored glass, though his palette was limited. The glass forms were arranged on pedestals, which housed transformers that generated a field of energy and lit up the inert gases inside the blown glass.

An encounter with a student expanded the more technical directions of his art. James Carpenter, a RISD illustration major with a strong background in botanical drawing and a fascination with architecture, approached Chihuly because he wanted to blow glass flower and seed-pod shapes in the spirit of the famed glass flowers of Leopold and Rudolf Blaschka at the Peabody Museum of Archaeology and Ethnology at Harvard University. Carpenter was well-traveled and an unusually sophisticated student, and the two quickly became good friends and commenced an artistic collaboration which continued through 1974. Pursued alongside Chihuly's busy teaching schedule, the collaboration of this teacher and gifted student took the form of an inquiry into what Carpenter has called "the characteristics of luminosity, reflection, and transparency." (conversation with the author, 1992) They moved on from illuminated botanical shapes to use plastic, dry and liquid ice, and neon in indoor and outdoor installations and environments and to create a group of architectural elements that includes a wall, windows, and doors of glass.

The use of neon and argon made possible a range and intensity of color that greatly expanded the expressive potential of their work. Neon has a red to orange range and argon is a whitish blue, which is increased in intensity with the addition of mercury. Brighter color can be added to neon and argon when their glass tubing is coated with fluorescent powder, and glass tubing can also be colored so that, beyond white and red variants, hues of green, purple, and blue can be attained. These advances were realized with the technical assistance of the Providence-area businesses of Bob Reed of Nepco Neon and Richmond Kent of Audio Applications. They helped Chihuly and Carpenter find the means, with considerable experimentation, to unite inert gases, high-frequency energy, and blown glass. Chihuly ordered masses of colored neon tubes from Nepco which he arrayed as "Neon Samplers" in simple displays on the wall of his studio. He became so interested in the artistic possibilities of neon that he taught classes in its use at RISD, and this medium is now a regular part of the Pilchuck Glass School curriculum.

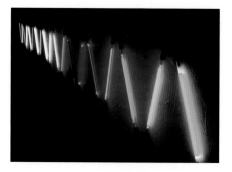

Homage to Bob Reed, 1971, neon tubes, 2 x 30 ft. x 4 in.

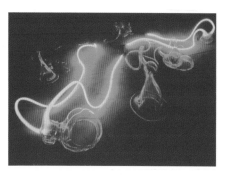

Uranium Neon Installation, 1971, glass, neon, argon, 15 x 15 x 15 ft., in collaboration with James Carpenter

Neon Experiment #17, 1971, glass, neon, argon, 10 x 12 x 12 ft., in collaboration with James Carpenter

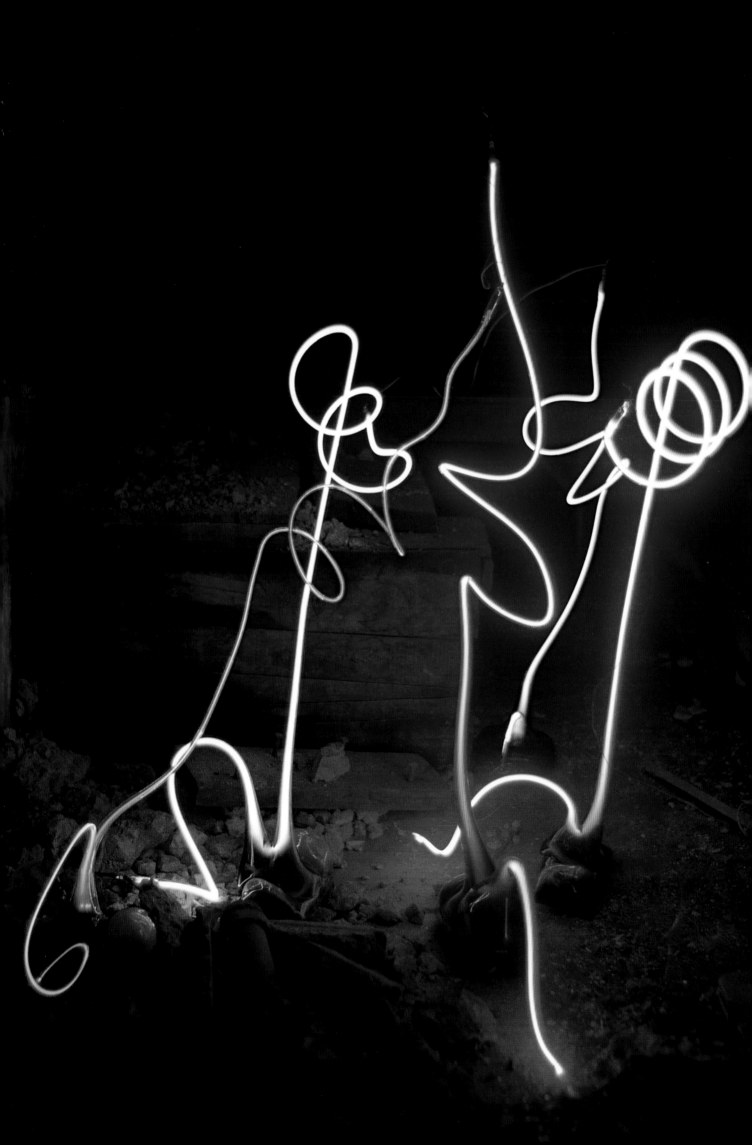

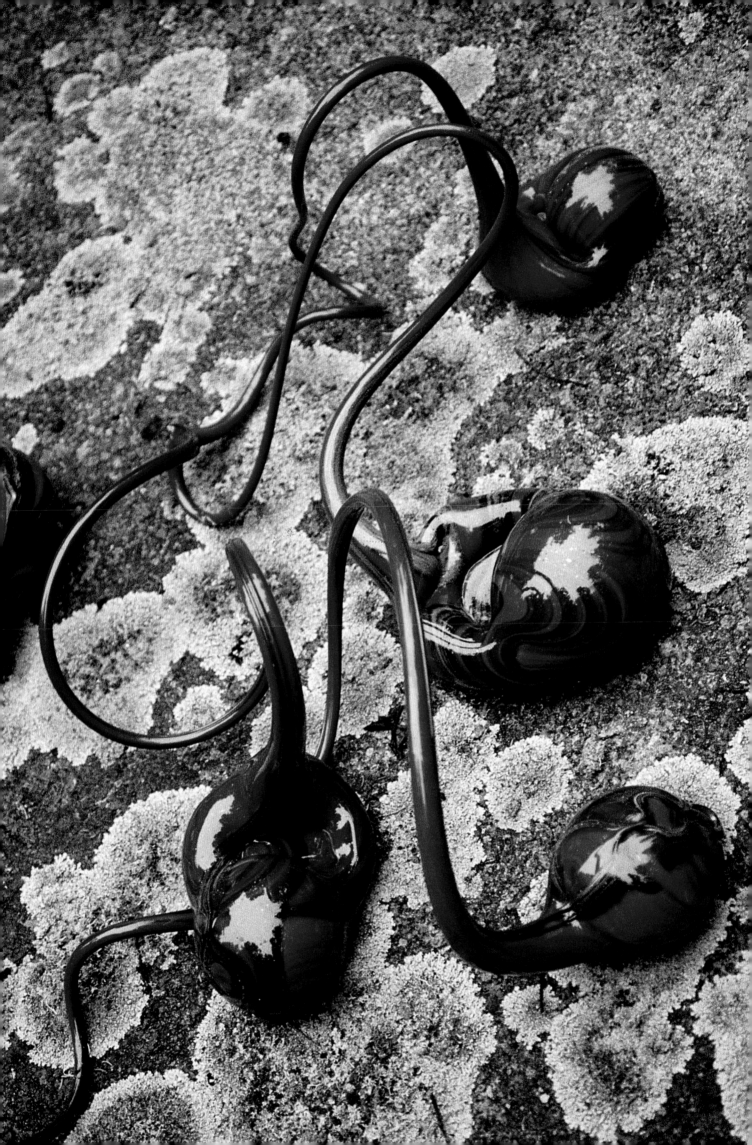

Haystack Projects
1970

During his first year at RISD, Chihuly heard about Haystack Mountain School of Crafts on Deer Isle, Maine, and he spent part of his next four summers there teaching glassblowing. Working with Carpenter in the late summer of 1970, Chihuly produced a series of brilliantly swirled red and black blown pieces, which the two then picturesquely arranged in a meadow and on the island's lichen-covered rocks. These installations exemplified the biomorphic and spontaneous foundations of their art. Chihuly had had to paint the glass bubbles in his earlier basement installation, but now he was able to blow colored glass, and together Chihuly and Carpenter became increasingly sophisticated about the technical and chemical aspects of glass.

Haystack Installation #5, 1970, glass, lichen, granite, 3 x 6 x 10 ft., in collaboration with James Carpenter

Toledo Glass National III
1970

Toledo, Ohio, had long been a center of commercial glass production and artistic innovation in the field of studio glass. In a garage on the grounds of the Toledo Museum of Art, Harvey Littleton, Dominick Labino, and Harvey Leafgreen began in 1962 their now-historic experimental glass workshop and classes. In 1968 the museum began an annual survey of contemporary art glass. These elite surveys recognized the leading talents in the field. Chihuly and Carpenter were invited to exhibit their newest experimental work in the fall of 1970.

Of the eleven artists included in the third survey, only they and Marvin Lipofsky submitted large objects. Chihuly's and Carpenter's elongated and organic, color-infused installation pieces were lengthy arcs of glass filled with neon and argon gases. From Carpenter came their exotic Latin botanical names: *Orchis Pubescence*, *Monotropa Uniflora*, *Physalia Deluxeus*, and *Medusae Superioris*. These sinuous arcs placed the two artists at the forefront of a movement begun at the Toledo Museum of Art to fuse the technical and creative interests that would shift American glass from functional objects to sculpture, but it was their breakthrough into bigger scale and their inclusion of neon that immediately established them in the vanguard of the studio glass movement.

Installation view, Toledo Glass National III, 1970, glass, neon, argon, 30 in. long, in collaboration with James Carpenter

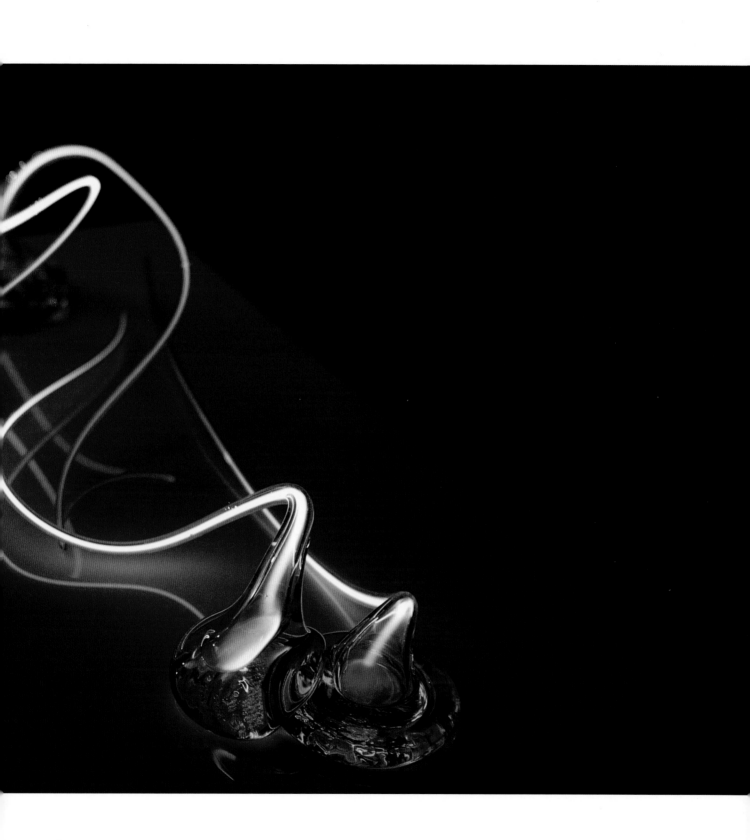

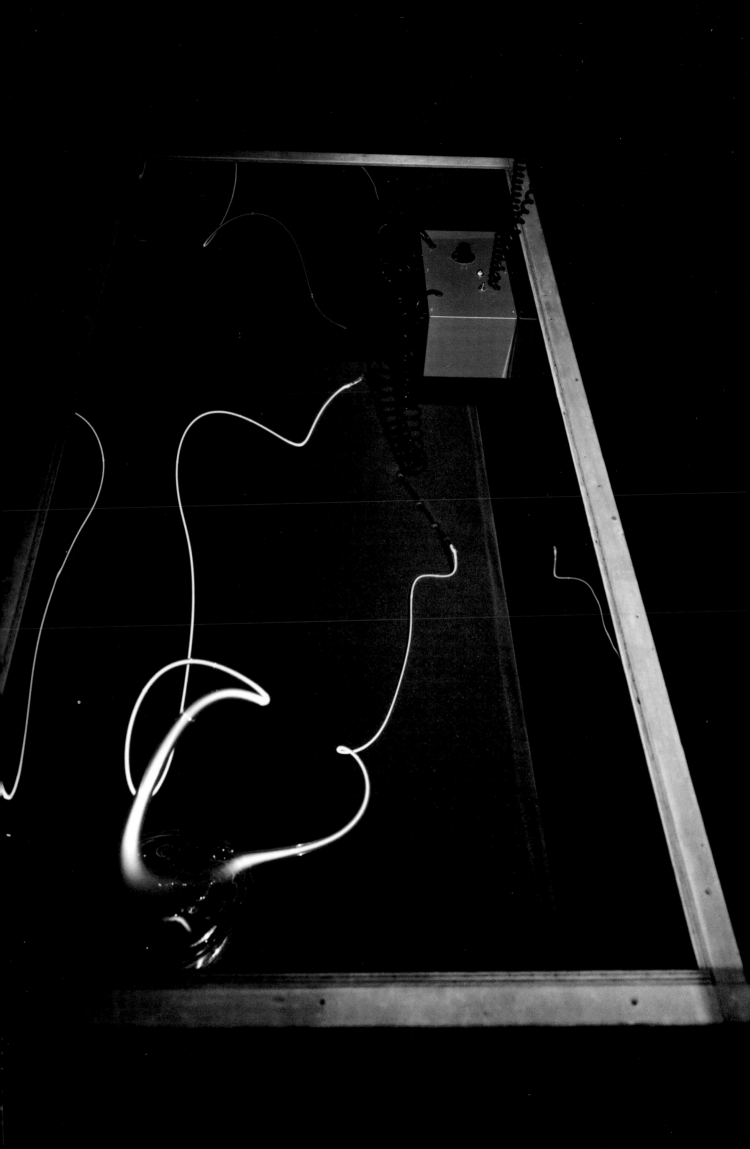

All the Way Out
to East Cupcake
1971

For the *1st National Invitational Hand Blown Glass Exhibition* at the Tacoma Art Museum in the spring of 1971, Chihuly and Carpenter exhibited a blown-glass and argon installation, complete with spiral power cord and transformer. The piece was presented in a coffinlike shipping crate, the top of which was removed to make the contents visible. It was described by museum director Jon W. Kowalek as "one of the most beautiful pieces in the show. . . . the excitement and plasticity of the medium seems to have reached its zenith." (Foreword, exhibition catalogue)

All the Way Out to East Cupcake, 1971, glass, neon, argon, 3 x 3 x 6 ft., in collaboration with James Carpenter

20,000 Pounds of Ice
1971

Inspired by the proximity of an old ice-house to Nepco Neon, Chihuly and Carpenter decided to combine neon and ice. At the Providence ice block manufacturer they placed an array of U-shaped neon tubes in about sixty standing molds filled with water, with the electrodes above the tops of the molds. The strength and slight flexibility of the glass tubing kept it from breaking as the water expanded and froze into 300-pound blocks of ice.

First unveiled in a memorable gathering for RISD students, faculty, and friends at the icehouse, the piece was later re-created outside the RISD art gallery in conjunction with the opening of the annual glass faculty show. *20,000 Pounds of Ice* was installed as a corridor at the entrance of the building, arranged in zones of similar hues. Some blocks were pushed and others fell over immediately, making their arrangement appear random. The piece took about ten days to melt. *20,000 Pounds of Ice* was the most beautiful and dramatic of the Chihuly/Carpenter installations. The opening of the Seattle Art Museum's 1992 exhibition is the only other time *20,000 Pounds of Ice* has been re-created.

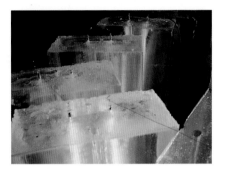

20,000 Pounds of Ice, detail

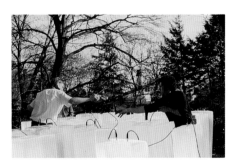

Carpenter and Chihuly at work on 20,000 Pounds of Ice

20,000 Pounds of Ice, 1971, 600 sq. ft., RISD, in collaboration with James Carpenter

Pilchuck Pond
1971

Among the early products of the two glass furnaces that were built in the initial weeks at Pilchuck Glass School were a series of clear biomorphic bulbs of glass blown by Chihuly toward the end of the summer. These ovals of glass were taken out to a nearby pond, floated on the surface, and photographed by the artist Buster Simpson. The floats, like the pond, disappeared by the end of the summer.

Such impromptu, site-specific projects set the tone of the first summers at Pilchuck and continued to push studio glass away from vessels toward more experimental and conceptual works. Recalling Chihuly's childhood fascination with the blue-green Japanese fishnet floats, these floating forms can now be seen as simple precursors of Chihuly's recent *Floats*.

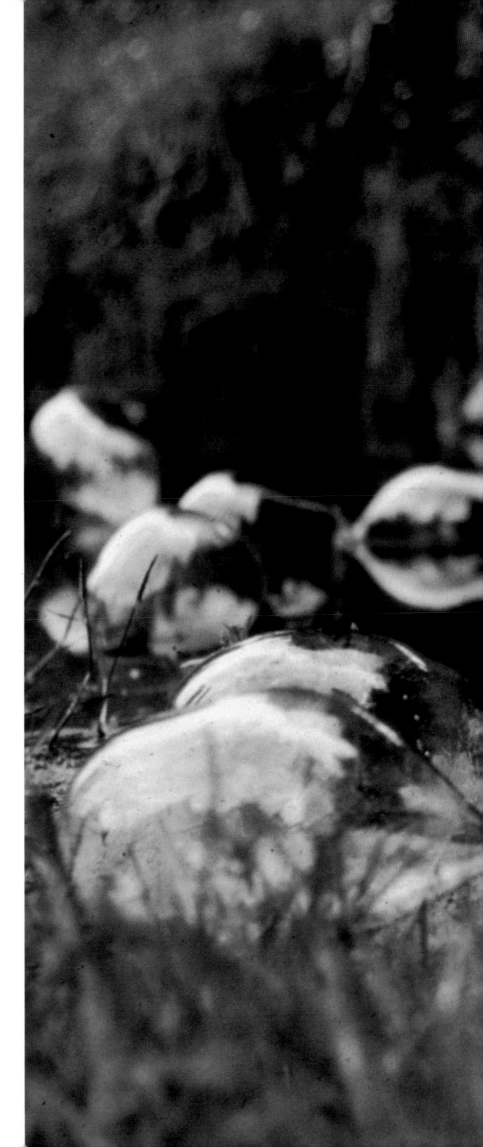

Pilchuck Pond
Installation
(detail), 1971

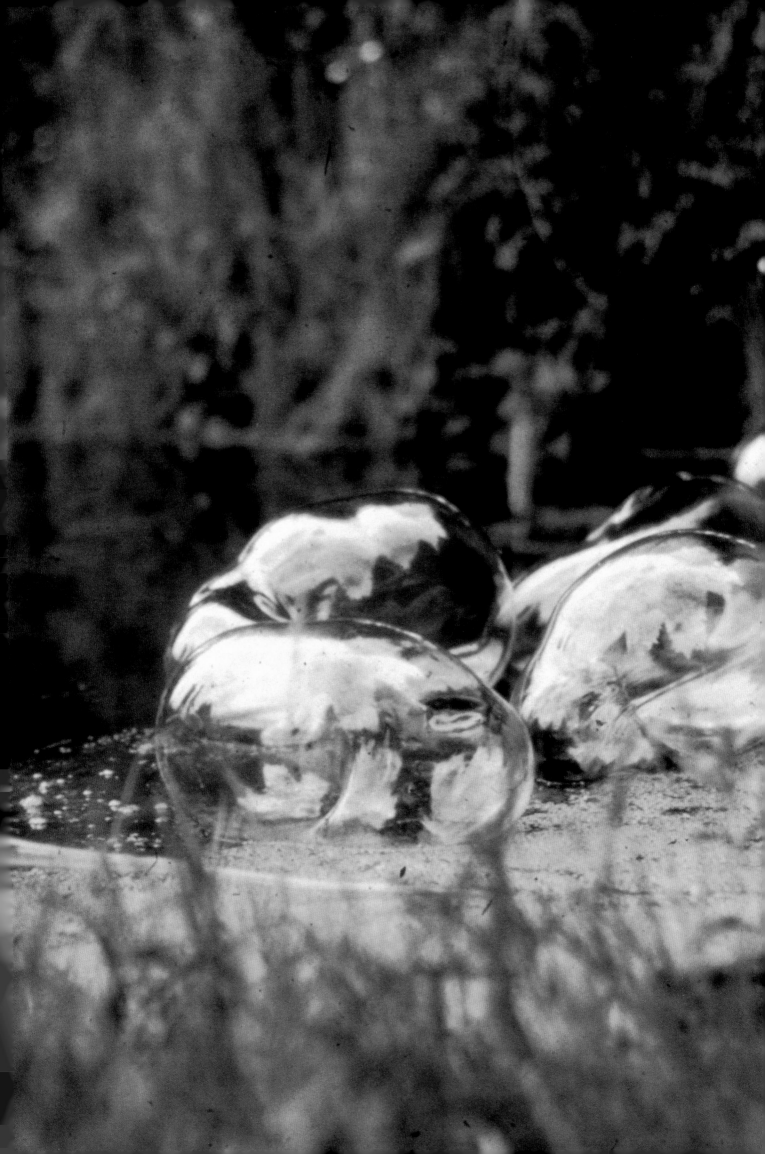

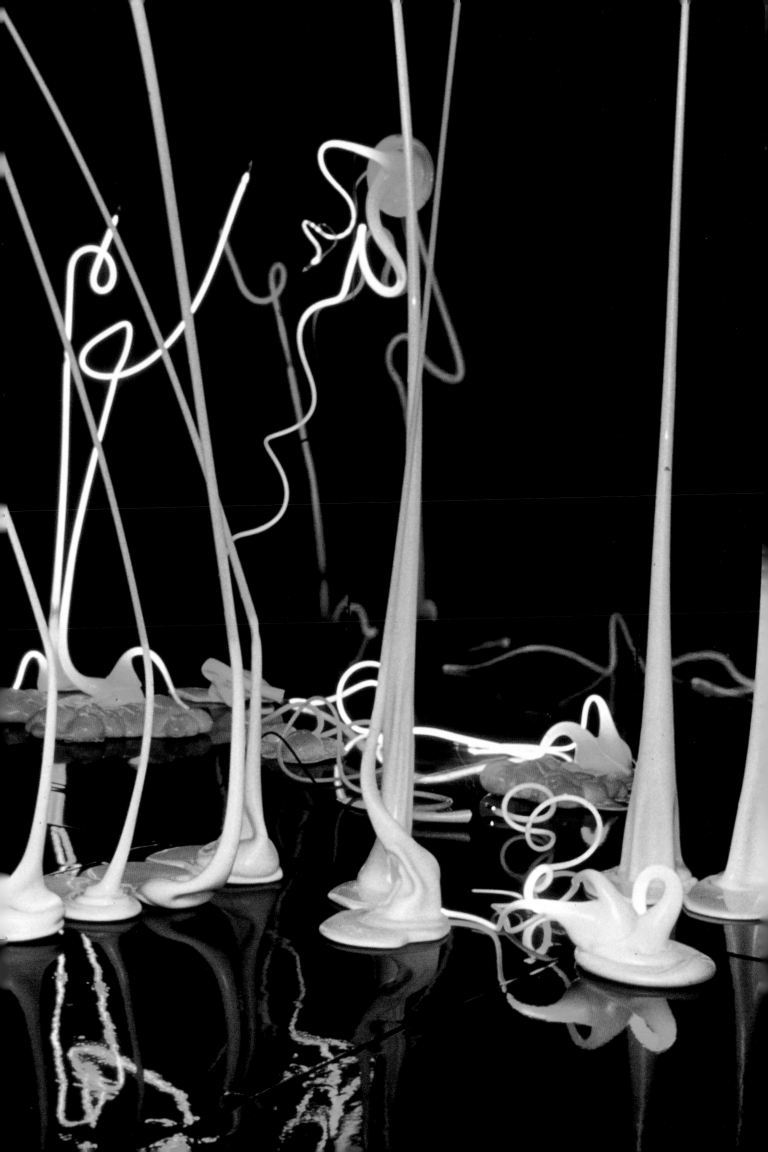

Glass Forest
1971–72

Chihuly's and Carpenter's best-known and most influential work of this period was an assemblage shown in 1971 and 1972 in two versions and in three different locations. *Glass Forest* consists of approximately one hundred, 6 to 9 feet tall, opaque white milk-glass stalks that rest upon the flattened residue of the molten balls of glass from which they were made. Similar elements mounted on the wall and, in Providence and Zurich, smaller elements coming from the ceiling completed this piece. All the elements of *Glass Forest* were illuminated with argon and mercury and clustered in enclosed spaces of about 500 square feet.

First installed at the Museum of Contemporary Crafts (later renamed the American Craft Museum) in New York City in a black Plexiglas and vinyl-covered space, the elements were then transported back to Providence to be reassembled in the general faculty show at RISD's Museum of Art in an all-white environment. On opening night Chihuly positioned a young woman (Eva Kwong) clad entirely in white within the installation, and Chihuly's next installation/performance of the piece in Providence involved several women dressed in white. From beneath the stage, the glass stalks were charged with high-frequency energy which caused color modulations when the women touched them.

Again in a white environment, *Glass Forest* was included in the important *Glas Heute* (Glass Today) exhibition at the Museum Bellerive in Zurich, Switzerland, in the summer of 1972. Chihuly's piece was the most ambitious sculpture in the show, and because of its eccentric form and innovative use of materials, it helped establish new directions for Europe's contemporary studio-glass movement.

With pieces such as *Glass Forest* and *20,000 Pounds of Ice*, Chihuly and Carpenter attracted wide notoriety and helped to redefine the studio-glass movement worldwide. Chihuly still considers the early 1970s one of the most creative periods of his life.

Glass Forest #2,
1971–72, glass,
neon, argon,
160 sq. ft.,
Museum of Art,
RISD, in collabora-
tion with James
Carpenter

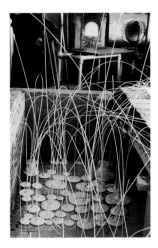

Glass Forest, 1971,
(work in progress)

Glass Forest #1,
1971–72, glass,
neon, argon,
500 sq. ft., Museum
of Contemporary
Craft, New York,
New York, in
collaboration with
James Carpenter

Other Neon Installations 1971–73

Chihuly fashioned several other neon and glass pieces from commercial neon signs and plain tubing. The neon was stacked and turned into assemblages and electrified, such as the now lost *Case of Beer*, made by Chihuly alone, who chose the wooden crate for its appropriate label, "handle with care," and the way it encased the three layers of stacked, commercial neon signs that spelled "BEER" in bright red.

Other Chihuly solo and collaborative works of this period used high-frequency, high-voltage coil transformers that illuminated the glass by radio transmission and enabled the viewer to alter the color by touch, as in the "performance" version of *Glass Forest*. Actively involved with high-tech, kinetic art of the period, Chihuly and Carpenter relied upon the technical creativity of Bob Reed and Richmond Kent.

With the exception of a few pieces retained by Reed and Kent, much of Chihuly's work of this period was destroyed when his Providence studio burned down in the summer of 1973, while he was teaching at the Pilchuck Glass School. Beyond the tragedy of this fire, Chihuly's installation art was, like so much of his site work of the late 1960s and 1970s, made to be ephemeral—fragile, experimental, and noncommercial. Most of Chihuly's and Carpenter's work of the early 1970s can now be seen only in photographs, which Chihuly actually prefers. A measure of Chihuly's indifference to the preservation of his work of this period is that he did not return to Providence immediately after the fire to salvage his work. Several friends did though, and remnants of this period's work can be found in the homes of friends and glass collectors in the Providence area.

Case of Beer, 1971,
neon readymade
and mixed media,
26 x 36 x 22 in.

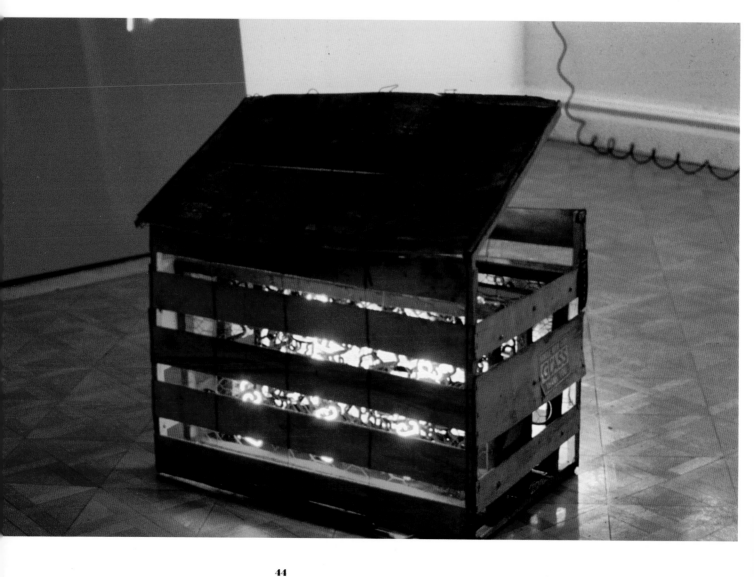

Dry Ice, Bent Glass and Neon 1972

Two very different pieces by Chihuly and Carpenter were included in the pivotal, widely circulated exhibition *American Glass Now*, organized by the Toledo Museum of Art and the Museum of Contemporary Crafts in New York. The fourth of Toledo's national surveys of glass, the show opened in Toledo in late 1972 and circulated to six other venues through the spring of 1974, including the Corning Museum of Glass, the Renwick Gallery of the Smithsonian Institution, the San Francisco Museum of Art, and the Santa Barbara Museum of Art. One work was transient and the other, *Rondel Door,* was the first of a group of architectural projects that the two artists pursued through the mid-1970s.

Dry Ice, Bent Glass and Neon was based on the form of an architectural elevation of London's Crystal Palace, built for the 1851 exposition and destroyed by fire in 1936. Chihuly and Carpenter considered this building the most innovative structure built in the nineteenth century and a key work in the history of glass. Enlivening the opening hours of the exhibition in Toledo and elsewhere, blocks of dry ice evaporated, leaving stacks of flat and curved sheets of glass on the gallery floor. For its brief initial stage at each venue, the piece, with its rising smoke and diminishing height, offered an abbreviated history of the Crystal Palace.

Dry Ice, Bent Glass and Neon, 1972, in collaboration with James Carpenter

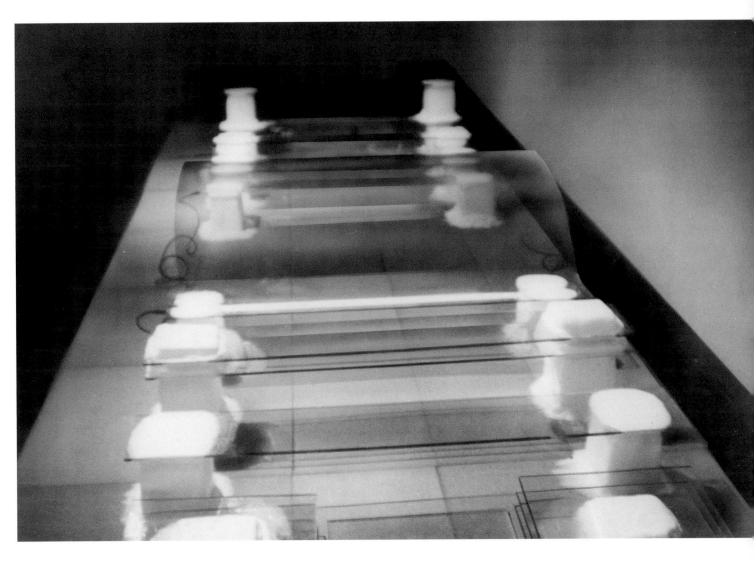

Glass in Architecture: Windows and Doors 1972–78

From 1972 through 1978, Chihuly and Carpenter directed their collaborative efforts toward making glass doors and windows that were amalgams of sculpture and craft defying categorization. Function was secondary both to design and the expansion of the artistic possibilities of the medium of glass. This aspect of their work allowed Chihuly to pursue an interest in interior design and Carpenter to work with architecture. They mixed blown, cast, assembled, and mosaic glass for these pieces and used writing and linear drawings to animate some of their surfaces, but their most interesting designs for doors and windows were non-pictorial and composed of geometric shapes.

Rondel Door, their first project in this series, was completed for the 1972 *American Glass Now*. The door's decoration and permanance were decidedly opposite to the austere, transient installation of dry ice, bent glass, and neon that also represented them. The door consisted of four blown rondels set with beveled plate glass in a unique lead came matrix. The caming, a grooved bar of lead used to hold together glass sections, was fabricated for them by Michael Kennedy, a Providence craftsman who now lives in Seattle.

With its distinctive raised swirls of color and linear arabesques, the door was an homage to both Art Nouveau and high-impact 1960s design. Of the two *American Glass Now* projects, it was the door, not the installation piece, that was illustrated in a *Newsweek* review (April 9, 1973) of the Toledo survey and brought the new glass movement to the attention of a broad public. *Rondel Door* was reserved for purchase by the Corning Museum but was damaged in transit from one of the survey's final stops. It was returned to the artists and then restored nearly twenty years later when Kennedy found another blown bull's-eye section that had been made in 1972.

After the exhibition, Chihuly and Carpenter received several commissions: a glass open wall insert for the Corning Glass Museum; a richly embellished and collaged window for the crafts division of the Australian Arts Council; and unique doors for John and Anne Gould Hauberg's Pacific Northwest Arts Center and the Pfannebecker Collection.

In an interview with Seaver Leslie, first published in the March 1975 RISD Alumni Bulletin and later reprinted in the August 1975 issue of *Glass Art Magazine*, Chihuly noted, "My concern is not with a limited audience, especially the gallery audience, which is too specialized for my present interests. I like to deal with the crowds off the streets who enter public buildings. It's a tremendous challenge and joy to get them involved in looking—to hold their attention."

This early commitment of Chihuly and Carpenter to decorative and functional art anticipated important changes that would take place in the art world over the next two decades. As Chihuly commented in the same interview, "We're going to see more and more artists turning towards decorative arts—particularly architectural arts. People are involved in making their own indigenous and personal places to live—they're sick of ready-made suburbia. And, now that cities are making it compulsory that one percent of a public building's cost goes towards art, I think that we will soon see some fresh approaches to architectural and decorative arts."

These architectural projects were the last series that Chihuly and Carpenter pursued together. Their collaboration was the most sustained and formal of Chihuly's career, though both artists have continued to work with architecture, and Chihuly has completed numerous large-scale commissions since the early 1980s. The concerns they articulated in the mid-1970s are still among the governing principles of their art. Though living on opposite coasts, they have maintained a friendship and periodically speak of collaborating again.

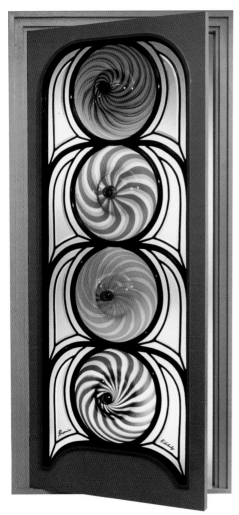

Rondel Door, 1972,
glass, lead came,
painted wood,
80 x 40 x 4 in., in
collaboration with
James Carpenter

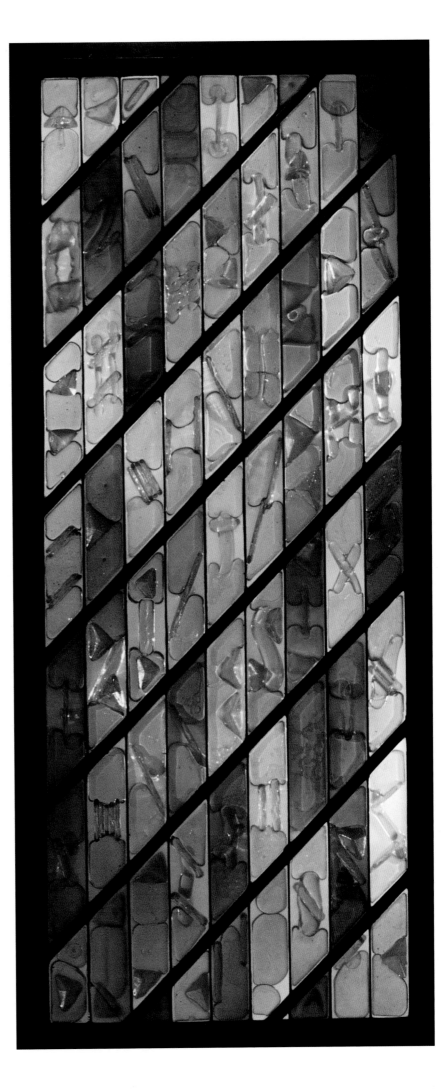

Cast Glass Door,
1973, cast glass,
steel frame,
80 x 40 x 3 in., in
collaboration with
James Carpenter,
Collection of
John H. Hauberg

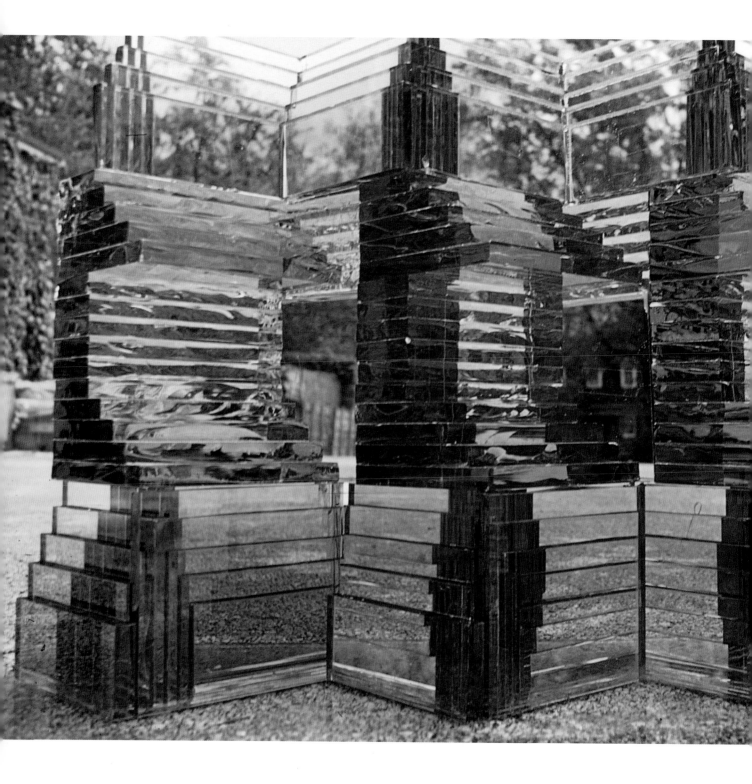

Mitla 1973

Though they may have been short-lived, both *Mitla* and the later Artpark project provided Chihuly an alternative to the organic shapes of his blown glass and a means to explore the minimalist sensibility so dominant during this period. In the winter of 1972–73, Chihuly traveled with Carpenter and Barbara Vaessen to central Mexico to the archaeological site of the stone necropolis at Mitla, near Oaxaca. He was fascinated by the fusion of Mixtec and Toltec influences and the intricately patterned walls of small stone slabs. These structures gave him the idea of working with glass blocks, so he ordered one thousand 3/4-inch plate glass blocks from Tennessee for shipment to a glassworks outside Philadelphia. The blocks came in five sizes, two hundred of each. Chihuly arranged them with geometric precision into a number of configurations. At Artpark in 1975, he again worked with plate glass, but with random configurations of thinner sheets. He abandoned the Philadelphia series because of problems with the adhesive.

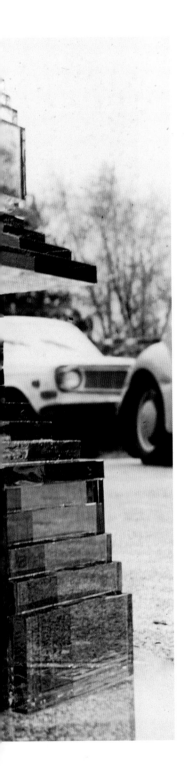

Mitla, 1972, 3/4 in. plate glass, adhesive, 40 x 40 x 12 in.

Institute of American Indian Arts, Santa Fe 1974

In the spring of 1974 Chihuly taught at the Institute of American Indian Arts, a study center and school for historic art and contemporary native artists. Working off-campus at a furnace in the desert near Sante Fe, Chihuly experimented with molten glass in a manner that broadened his thinking about installation.

Hot glass spewed across the dirt floor of the elementary glassworks he had created there in what was conceived as an intentional "accident," re-creating the flood of sizzling glass in a photograph showing the outpouring of a glass furnace in Scotland. Chihuly made several experiments that he captured in photographs, with no further thought to their durability.

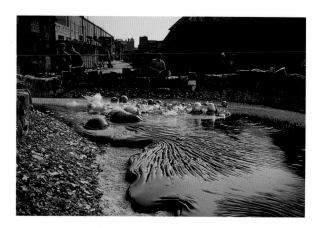

Scottish glass factory, emptying furnace, c. 1960

Glass pour, 1974, American Indian School, Santa Fe, New Mexico

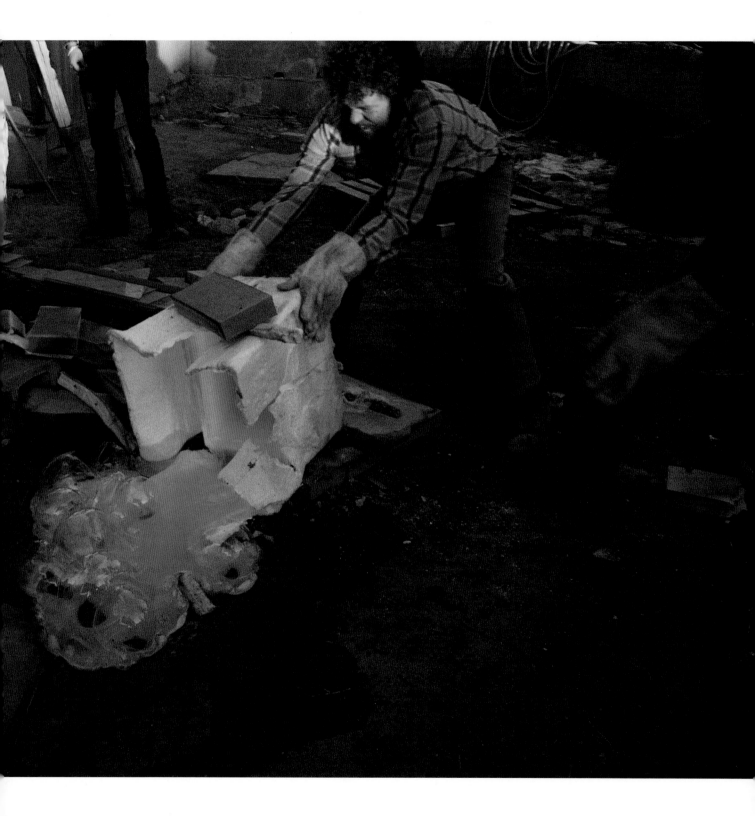

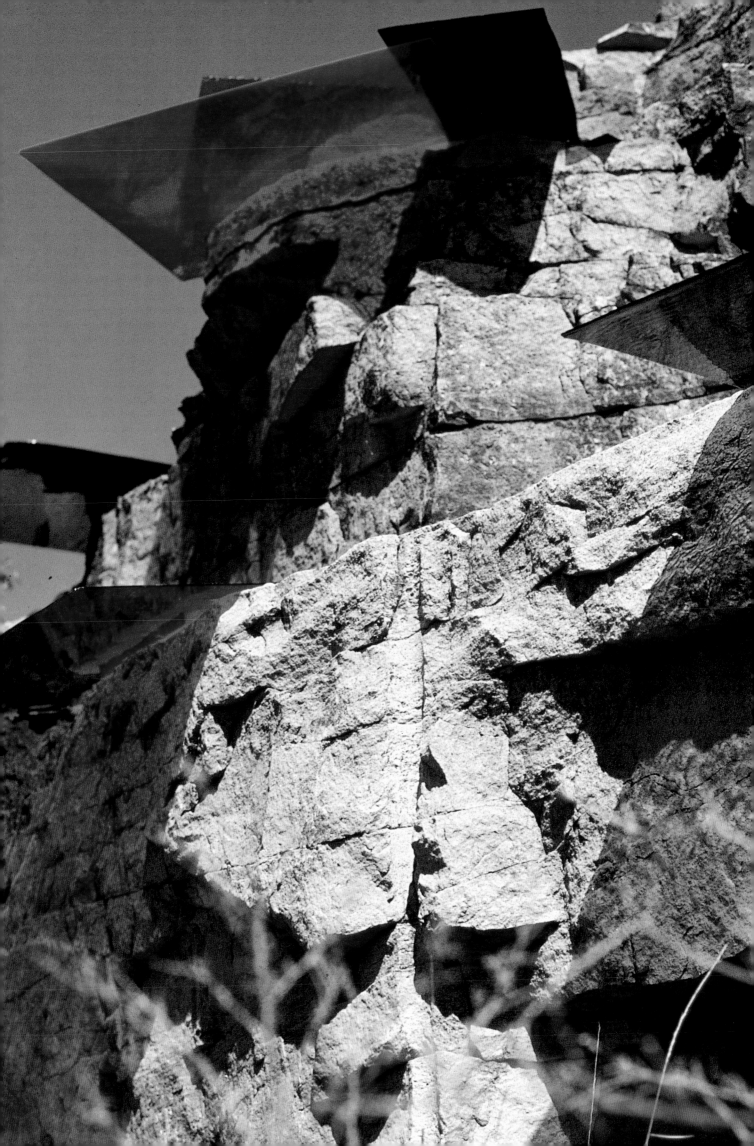

Artpark
1975

In the summer of 1975 Chihuly was among the nearly forty artists (including Dennis Oppenheim, Robert Grosvenor, and Alan Saret) invited to create temporary, site-specific work at Artpark, a public park and land reclamation site in Lewiston, New York, near Niagara Falls. It was the second summer of this continuing program in which artists are asked to work out-of-doors and permit the public to watch and interact with them. Chihuly was invited to collaborate with his old friend Seaver Leslie, a RISD graduate in painting. For about ten days in late August and early September they created a series of temporary installations using thin sheets of German-made colored glass. They had help from the artists Kate Elliott, later Chihuly's assistant and now a dealer of contemporary glass, Paul Inveen, Benjamin Moore, and Phil Hastings.

The most transient of his projects, more like minimalist stage sets than sculptures, the Artpark pieces are Chihuly's most spontaneous and ethereal works. He and his friends moved the fragile sheets around the park site, photographing single and clustered sheets of glass both indoors and in the landscape. The team pieced together multi-paneled windows, fitted single sheets into the crevices of the site's sheer stone walls, lined up sheets in the culvert of a waterfall that fell into the Niagara River, and stuck them into the mud in the shallows at the river's edge. Reflection, refraction, and shadow were the substance of these pieces lit by sunlight, with mirrors, battery-powered flashlights, candles, and fire.

As always, Chihuly and his collaborators made extensive photo documentation of the illuminated color and shape of the rectangular sheets of glass playing off the architecture of their quonset hut studio and outdoors against the land, water, and sky. As Chihuly later remarked, only in reviewing the photos of his Artpark residency did he realize how much he had learned in those ten days, both about the uses of color and the extensive possibilities inherent in site-specific projects.

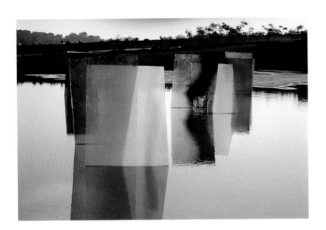

Artpark Installation #4, 1975, in collaboration with Seaver Leslie

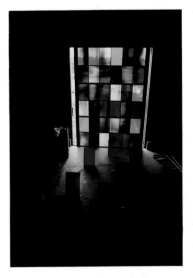

Artpark Installation #7, 1975, 18 x 10 ft., in collaboration with Seaver Leslie

Niagara Gorge Installation, Artpark, 1975, in collaboration with Seaver Leslie

Shaare Emeth Synagogue Windows, Saint Louis, Missouri 1980

In conjunction with the construction of a new building, the Shaare Emeth Synagogue in Saint Louis commissioned Chihuly to make windows for its contemporary design. He conceived six two-part windows of descending height, three to each side, to frame the *bema* (altar) of the main sanctuary and, with Heiki Seppa, a Saint Louis metalsmith, the synagogue's *ner tamid* (eternal light), which is placed over the arc doors on the *bema*.

Chihuly was chosen by a committee whose chairman, Roger DesRosiers, then Dean of the Washington University School of Fine Arts in Saint Louis, had worked with him on several previous projects. In typical fashion, Chihuly enlisted the help of two former RISD students, Eve Kaplan and Eric Hopkins, to assist with the conceptual (Kaplan) and technical (Hopkins) aspects of the work. The six double windows were divided

three on each side of the *bema* and symmetrically stepped back from 20 to 16 to 12 feet high. Each pair of windows was made in shades of gray and red, symbolizing the Biblical subject of the "pillar of smoke by day and the column of fire by night that led the Israelites through the desert after they left Egypt." (Patsy Degener, *Saint Louis Post Dispatch*, December 29, 1980) Seppa's stainless-steel casing enclosed Chihuly's cylinder of roseate glass with surface drawing, which surrounded a permanent gas flame.

Chihuly made numerous preparatory drawings in Providence and worked out a complex, variable color system for the columnar motif that moved from cool to warm shades of gray and red both vertically and horizontally. As Patsy Degener's article asserted, "The color changes in each separate panel are so subtle and varied that they are more like color field painting than the static color divisions separated by lead of traditional stained glass. With no lead divider between colored column and transparent background glass, the columns seem to float. Occasionally delicate drawings are etched into the surface. . . . one can become lost in the individual panel, seeing it as an ephemeral, evocative landscape, and yet remain aware of the entire screen as a visual architectural element of the building."

Chihuly's vertical panes are freestanding in front of the temple's functional clear windows, and he textured the flat glass panels by acid-etching them. The panels were of the same type of glass he had used at Artpark five years before. Although this piece appears to be unlike anything Chihuly had ever done before, it connects to the panoramic Artpark window and the other Chihuly/Carpenter architectural window collaborations of the early and mid-1970s.

Studio, 1980, Providence, Rhode Island

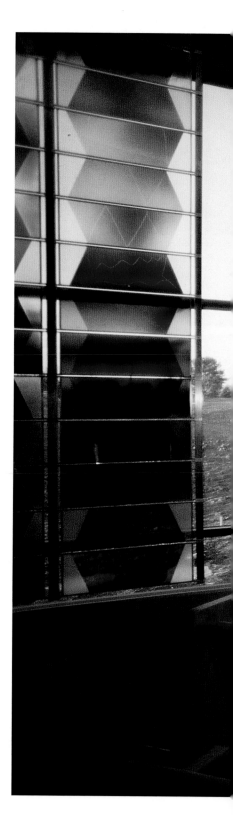

Shaare Emeth Synagogue, 1980

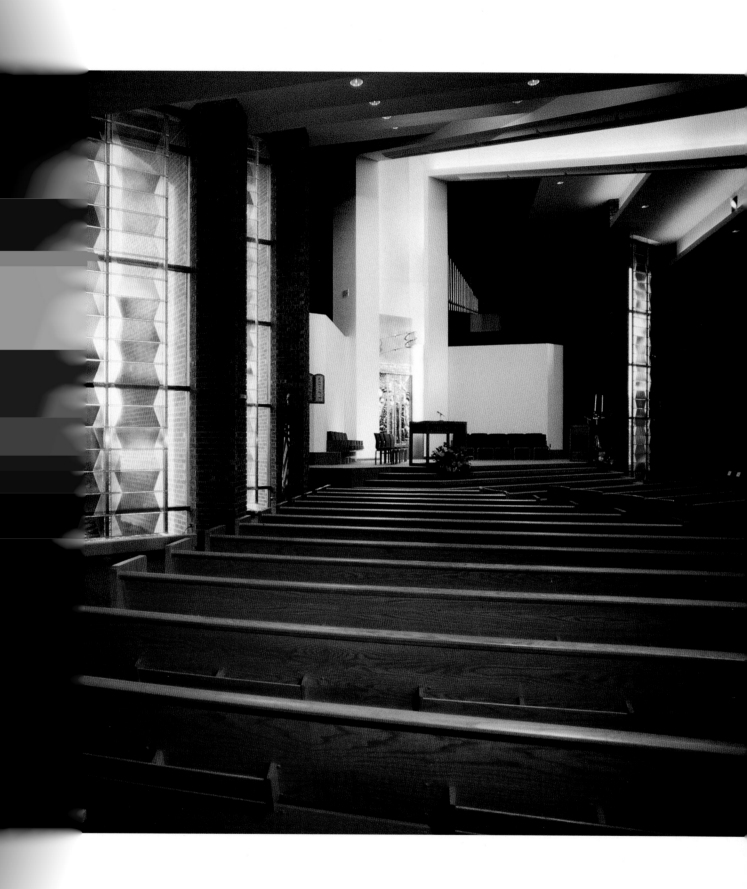

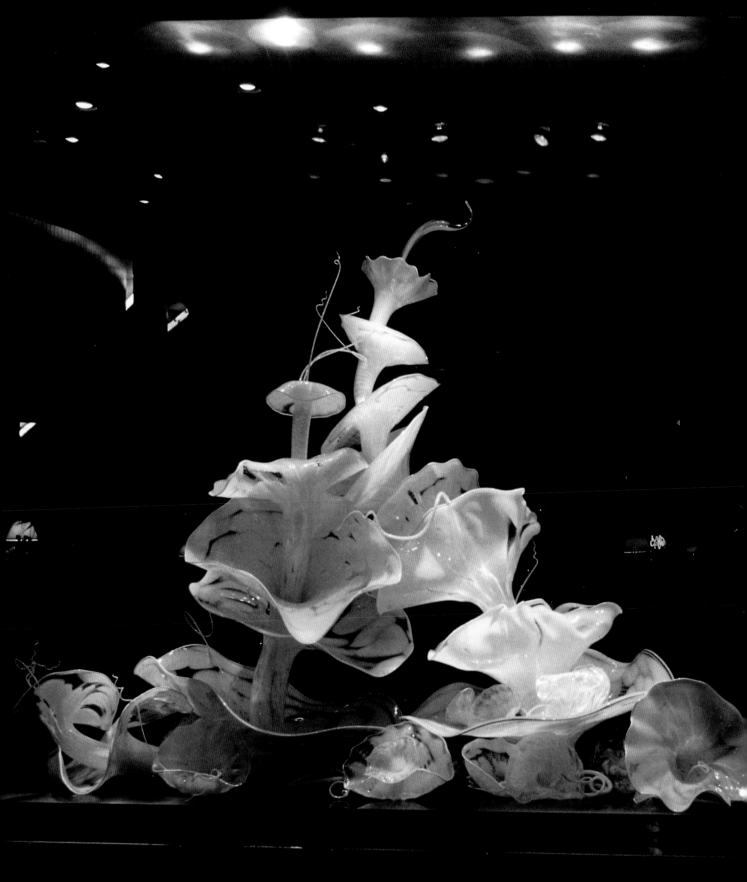

Public Installations 1985–92

Chihuly's multi-part *Seaform, Macchia, Soft Cylinder,* and *Persian* forms lend themselves to large-scale installations. Through art consultants, public and private art dealers, and his profusion of friends and acquaintances, commissions of his work began to grow dramatically from the early 1980s on. The accelerating tempo of the U.S. economy in the 1980s can be charted in Chihuly's corporate and institutional commissions, glistening embellishments for the decade's increasingly grandiose buildings. This aspect of his work continues into the present with two of his largest commissions underway, a panoramic window and his largest wall assemblage to date.

While several of the more than thirty Chihuly installations of the 1980s and 1990s are examples of large multi-part Chihuly pieces purchased from galleries or from the artist by corporate art advisers and located in lobbies or other public spaces of office buildings, most were site-specific commissions. As indicated in his 1975 interview with Seaver Leslie, Chihuly had foreseen this integration of art and architecture. However, he had believed that this move toward having works of art in public places would be initiated by architects rather than by the entrepreneurs, building owners, and real-estate developers whom he now credits with the growth in this form of public art.

For Chihuly, the development of these public and semi-public commissions began in 1979, when he was awarded a General Services Administration commission for an installation at the U.S. border town of Blaine, Washington. Chihuly gathered together a group of single and nested *Baskets* in a static traditional display. His next commission for the windows at the Shaare Emeth synagogue in Saint Louis County provided the most challenging opportunity for Chihuly to work with architecture, rather than encased work that simply adorned the site.

The majority of his later commissions were for clusterings of pieces presented as organic and sensuous focal points in stark, modern lobbies. In 1984 a large, white *Seaform* grouping was acquired for a dramatic black setting at the center of the entry area of the Tacoma, Washington, Financial Center building. The next year Fleet Bank in Providence, Rhode Island, commissioned an installation. In 1986 the Seattle Sheraton Hotel had a large freestanding case built as a columnar architectural element in the lobby to contain a rare group of Chihuly's white floral forms. A layered and more complex installation for the orientation area of the Seattle Aquarium in 1987 indicated his growing sophistication with massing and displaying his work.

In the mid-1980s for an installation in the Rainbow Room, a private dining room sixty-five stories above Radio City Music Hall in New York City, Chihuly mounted his glass elements on the wall. Chihuly's participation was suggested by Henry Geldzahler, the former curator of modern art at New York's Metropolitan Museum of Art and a major supporter of the artist. Chihuly was given the largest space among the artists commissioned. The installation, completed in 1988, spans three walls of the room, with a unifying range of sunset tones. The elements glow above spectacular Manhattan vistas. Spurred by the success of this project, he has actively sought opportunities to create large wall-mounted, multi-piece installations ever since.

Pilchuck Basket Installation, 1979, U.S. Border Station, Blaine, Washington

Flower Forms #2, 1986, 6 x 5 x 4 ft., Sheraton Seattle Hotel and Towers, Washington

First overleaf: *Rainbow Room Frieze,* 1988, Rockefeller Center, New York, New York

Second overleaf: *Persian Installation* (detail), 1988, glass, 6 x 14 x 12 ft., Chancellor Park, San Diego, California

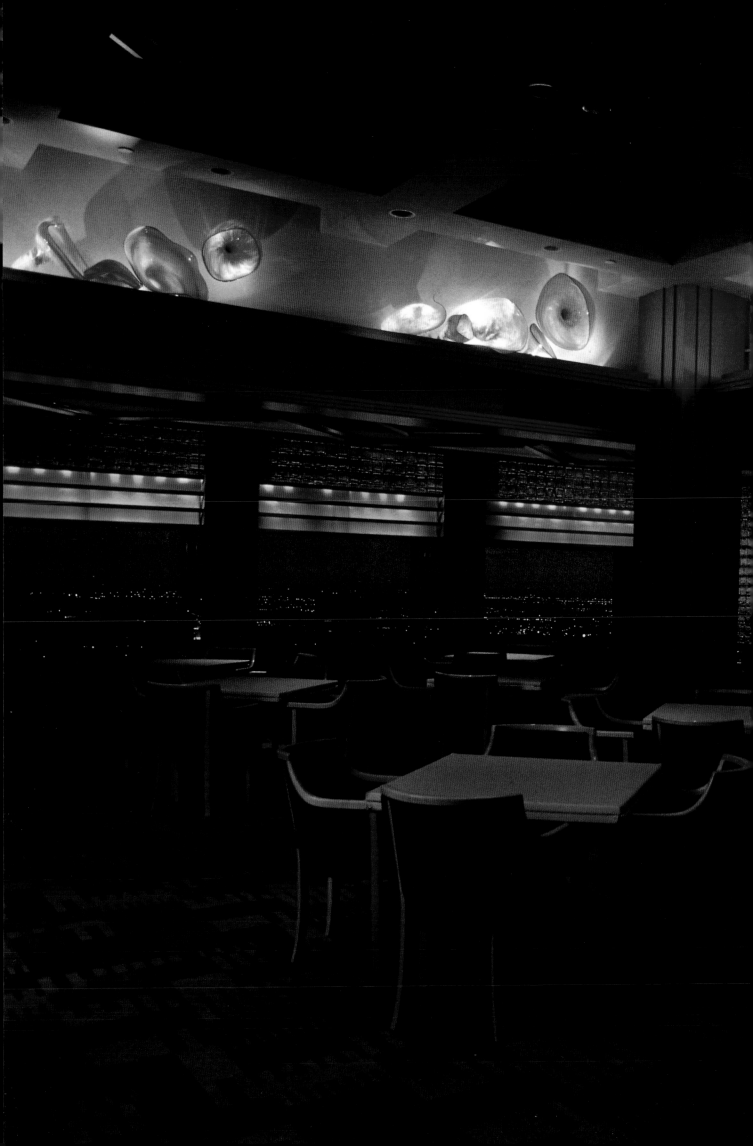

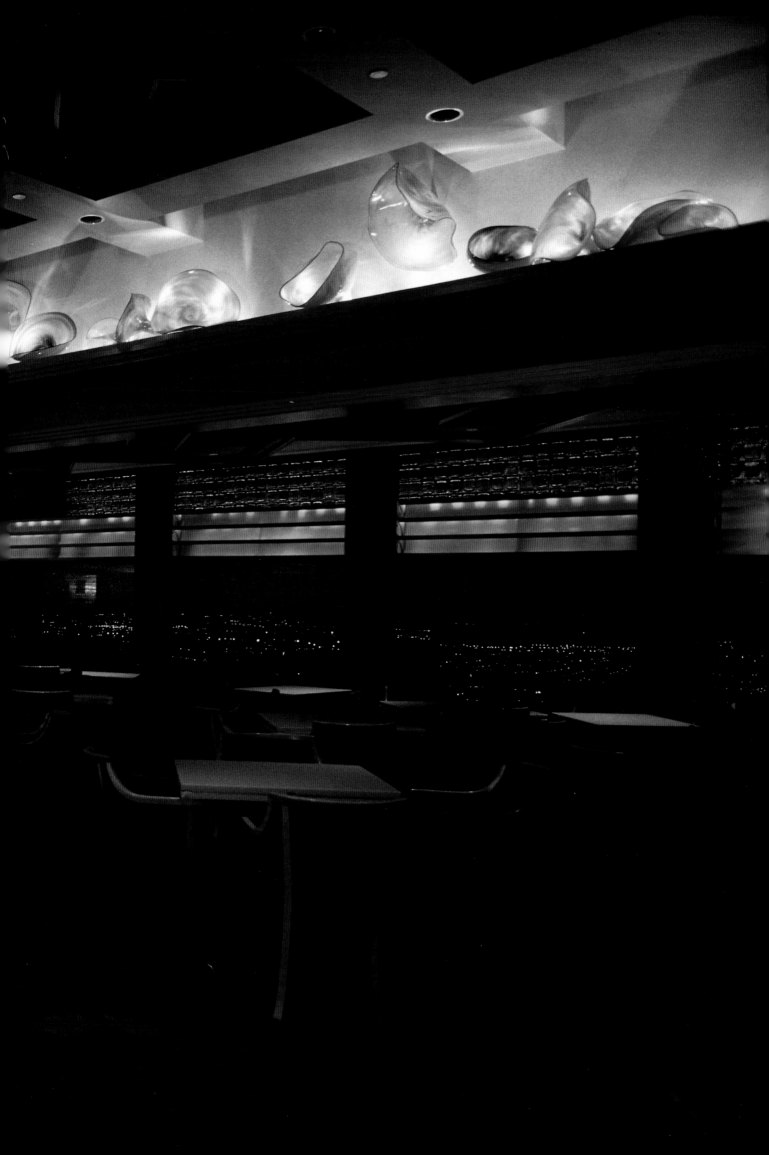

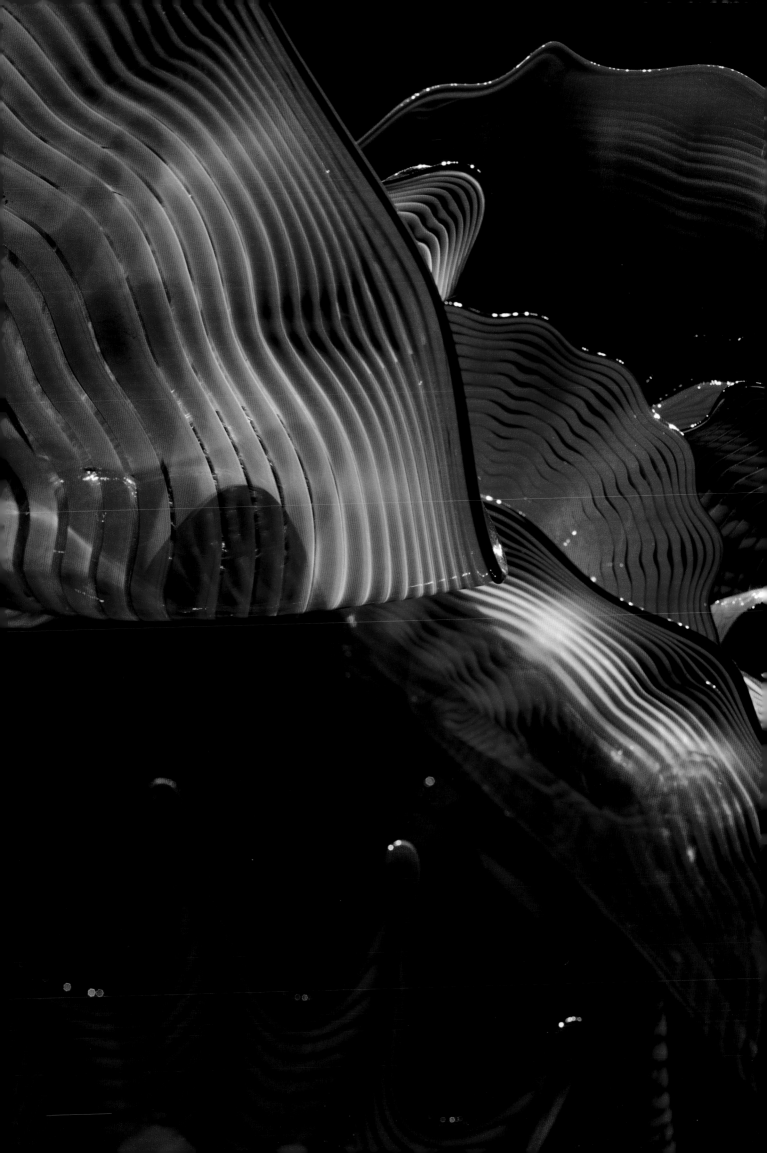

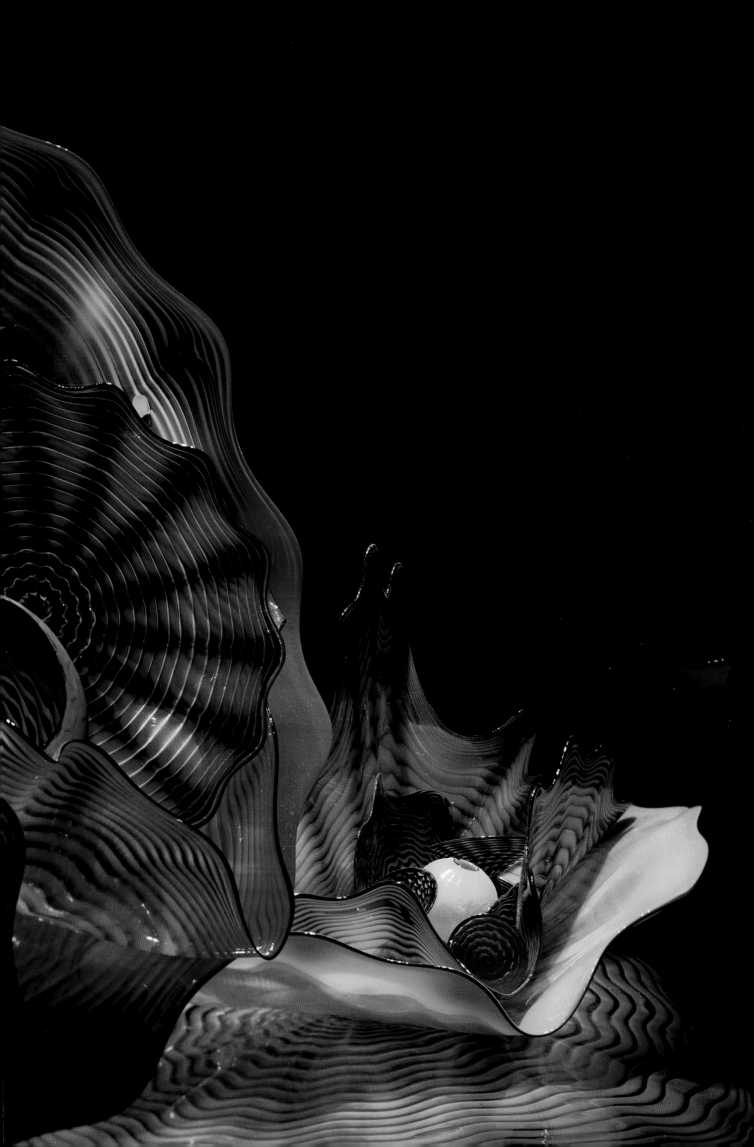

Chihuly's annual exhibitions at Charles Cowles Gallery from 1988 to 1992 included wall-mounted and, with the *Floats* in 1992, floor-based installations. The wall-mounted glass clusters in Chihuly's 1990 installation were aptly compared by David Bourbon to "flamboyant corsages. . . . commanding attention both for the sheer gorgeousness of their undulating forms and for the spectacular manner in which they spill into the room. Biomorphic shapes whose intricate and ornate edges seem all but alive with potential movement." (*Art in America*, August 1990, pp. 164-66, 203) Carefully lit by Chihuly, the irregular edges and variegated glazes of their multiple elements send sinuous shadows and patterns of color across the wall.

Since 1987, when Chihuly built his first Seattle hot shop, he has explored many new ideas and extensive mock-ups. His work has increased in scale, and his palette has become ever more adventuresome, all in step with a sequence of major commissioned pieces that have established Chihuly's reputation as a public artist. Notable among his recent works are the 1988 *Persian* installation at the Chancellor Park office complex in San Diego, California, and a permanent installation of his work, in memory of his father and brother, at his hometown Tacoma Art Museum. The Tacoma "retrospective" includes early *Baskets*, a vivid red *Venetian*, *Seaforms*, *Macchia*, *Cylinders*, and several drawings. Other public projects were also completed in 1988 for the Hyatt Hotel in Adelaide, Australia, and for the entrance lobby of the Frank Russell Company in Tacoma, Washington. In 1989 in keeping with the often aquatic appearance and inspiration of so much of his art, Chihuly made three groupings of works for a public area of the *Oceanic Grace* cruise ship. His 1991 25-foot long grouping of open *Persian*

forms decorated an underground passageway of GTE's massive world headquarters in Dallas, Texas. His selection for this project along with the sculptors Judy Pfaff, James Surls, and Robert Longo confirmed the growing esteem for his work as a sculptor.

Many installations for these recent commissions are as ornate and decorative as some of the 1970s Chihuly/Carpenter installations were high-tech and austere. Although the progress from his RISD glass environments of 1971 to 1972 to the GTE commission over twenty years later is extraordinary, it should not be exaggerated, for much of later Chihuly can be seen in his early work. While Chihuly's technical capacities as a glassblower and colorist have advanced to a startling degree since the early years of electrically charged neon, the ideas and the creative energy have been present since the beginning of Chihuly's art.

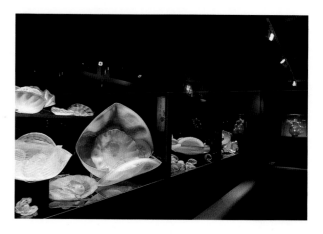

Chihuly Collection, Tacoma Art Museum, Washington

Pacific First Persian Installation #2, 1991, Seattle

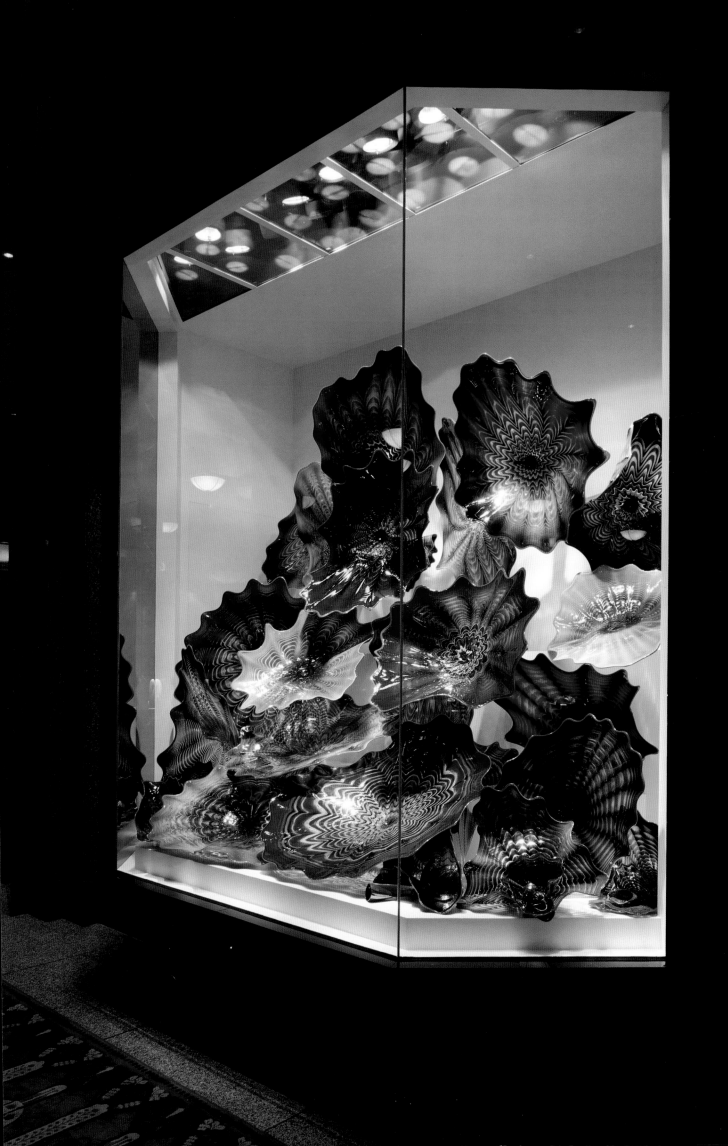

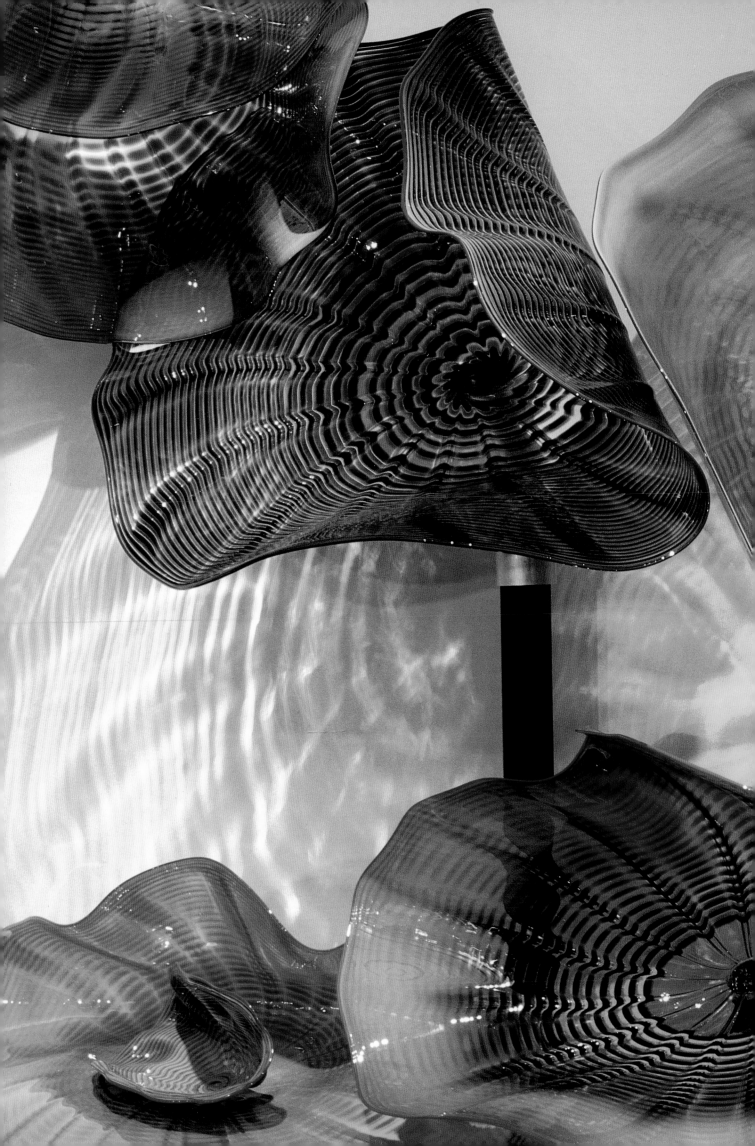

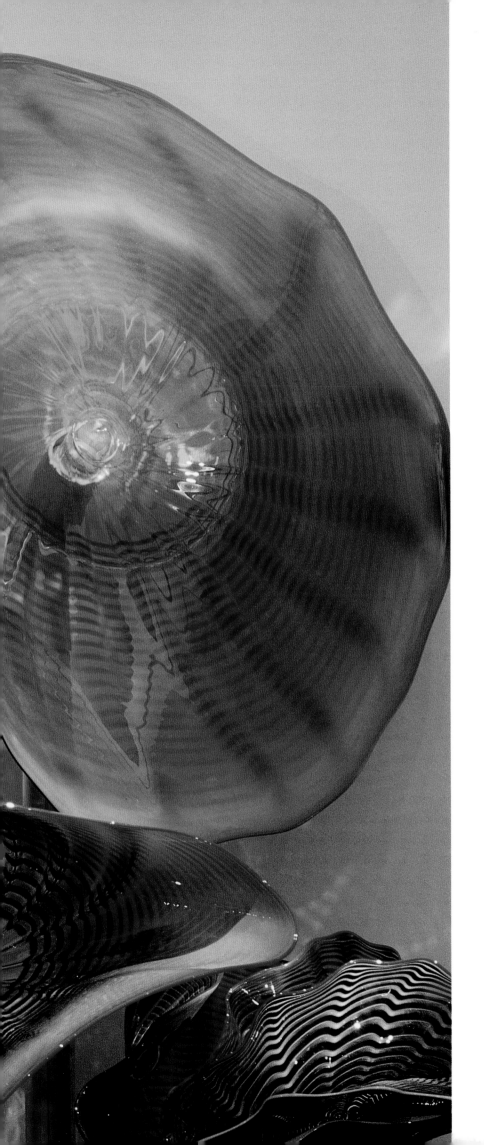

Private Architectural Commissions 1989–91

In addition to his impressive and often dramatically scaled corporate and institutional installations, Chihuly has received several major private commissions. In 1991 he traveled to Japan to install a group of his works beneath a glass floor amid the sumptuous glass collection in a 850-year-old Shinto shrine in Kyoto. For collectors in Philadelphia, the Seattle area, and elsewhere, he has fashioned and carefully illuminated assemblages of blown-glass elements. In at least two instances these installations were placed on stairways to take advantage of complex spaces and for the drama of having the work seen at eye level as well as from above and below. Emerging from the flatness of the wall, the glass forms and their expanded, shifting shadows dematerialize form and color.

Shirley Wall
Installation, 1988,
7 x 10 x 3 ft.

Floats

1991–92

In late 1991 Chihuly started a series of works that replaced the convolutions of his *Venetians* and their variants with the simplest forms of his career. Once again, he renewed his art by increasing the scale and moving off in some very different direction. The idea came from the small blue-green glass floats from fishing nets he encountered along the seashore during walks he took with his family as a child. He was reminded of this memory during a 1991 visit to Japan. When he returned to Seattle, as Chihuly noted in 1992, "I started the floats in an odd way, as many series begin. I told Rich Royal and the team to blow as big a ball as they could and to put a dimple in the end so that we could stick a smaller ball on top of it that would have flowers attached. The idea was to make the largest Venetian that I could—hopefully six to eight feet tall. Looking at these balls after they came out of the oven, I decided that they looked pretty good on their own."

The floats are Chihuly's first series made to be placed directly on the floor, and this placement underscores the simpler design and more sculptural aspects of the series. Though individual *Floats* have been seen alone, they are that much more effective when massed together as they were in early 1992 at the American Craft Museum and the Charles Cowles Gallery. These simultaneous exhibitions of the new series were offered in strikingly different ways: sunlit and spread out on a bed of broken clear glass inside a large window facing the street at the American Craft Museum and isolated in the darkened, spotlit expanse of the Cowles Gallery. The acquisition that spring of a pair of *Floats* by the Whitney Museum of American Art confirmed Chihuly's conviction about the aesthetic importance of glass and the Whitney's pioneering commitment to contemporary art.

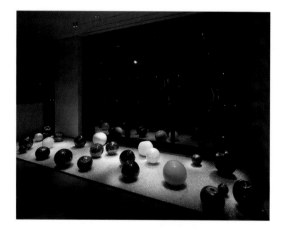

**Niijima Float
Installation, 1991,
glass, 4 x 40 x 15 ft.,
American Craft
Museum, New York,
New York**

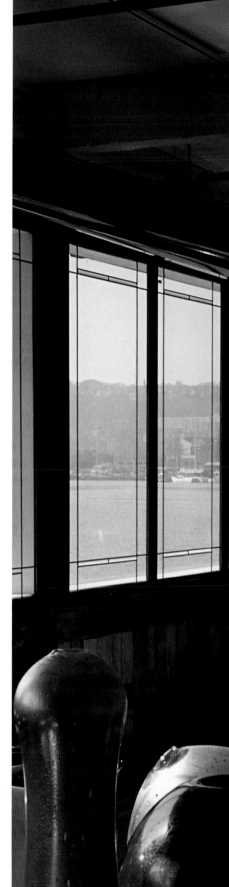

**The Boathouse,
1991**

66

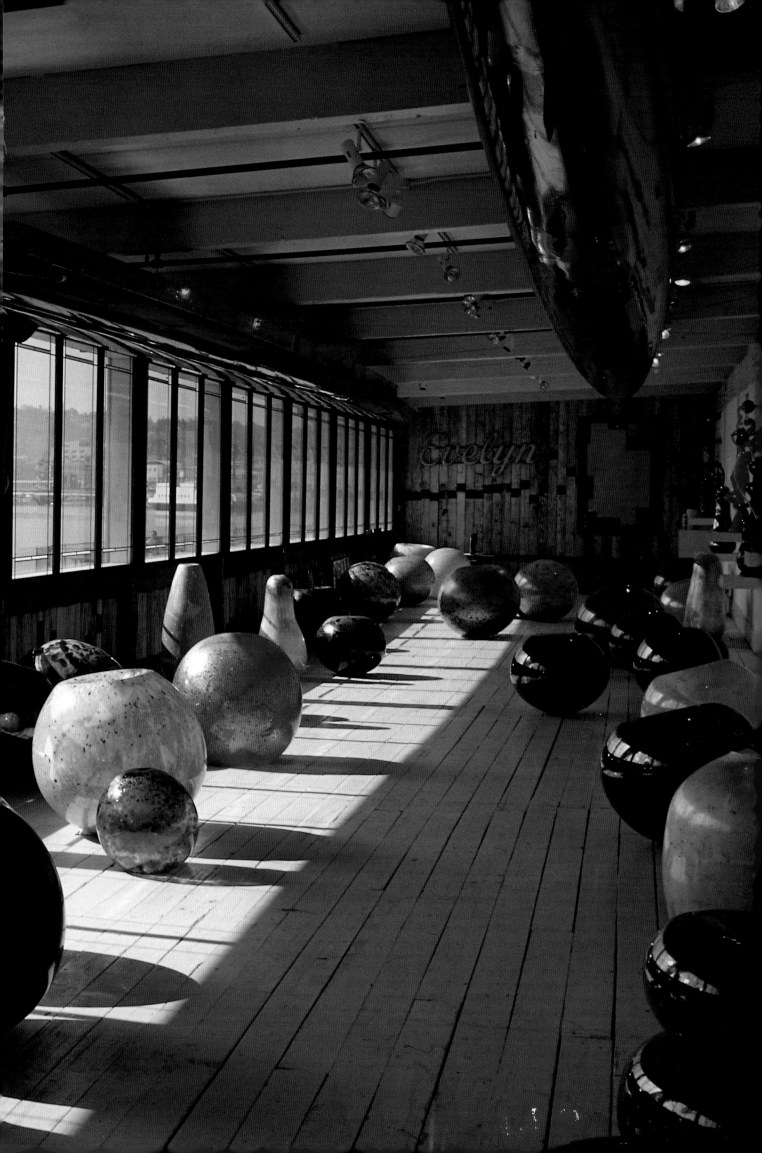

Seattle Opera Set for Claude Debussy's *Pélleas et Mélisande* 1992–93

Seattle has become increasingly well known for its opera company under Speight Jenkins's leadership. At the invitation of Jenkins, Chihuly initiated early in 1992 a set design for Claude Debussy's opera *Pélleas et Mélisande*.

Though he has never attended the opera regularly, it is through his friendship with the artist David Hockney that he saw firsthand the tremendous challenge and possibilities of the form. The five acts and fifteen scenes of Debussy's opera provide an opportunity for exploring a full range of design and lighting possibilities. As Jenkins must have known, this particular opera offers a very appropriate vehicle for Chihuly, for, as Douglas Allanbrook has written, "The effect of the words and the effect of each scene is like a ring dropped in a forest pool. The music surrounds and deepens the words and the actions, not in any thorough-going fashion full of rhetorical cadences and flourishes, but in a manner that can only be deemed symbolic and reflective." (*Brief Lives: A Biographical Companion to the Arts*, Atlantic-Little, Brown, 1965, p. 207)

For the set Chihuly immediately considered how he might use glass but quickly switched to other transparent materials, and his early fascination with weaving and fiber arts was renewed with the innovative theatrical textiles and synthetic fabrics that he found for this project. These fabrics became the starting point for his design and the impetus for the final section of the installation that he was planning for the Seattle Art Museum survey installation. This concluding installation focuses upon Act One, Scene One. The set is a forest, which will be, in Chihuly's words, "mostly transparent, shimmering, luminous. . . . abstract and very simple." Chihuly's greatest challenge to date, the set for *Pélleas et Mélisande*, affirms both the central role of installation in his art and his ongoing accommodation of new challenges.

Drawings for opera set, *Pélleas et Mélisande*, 1992

Act One, Scene One (mock-up), 1992

70

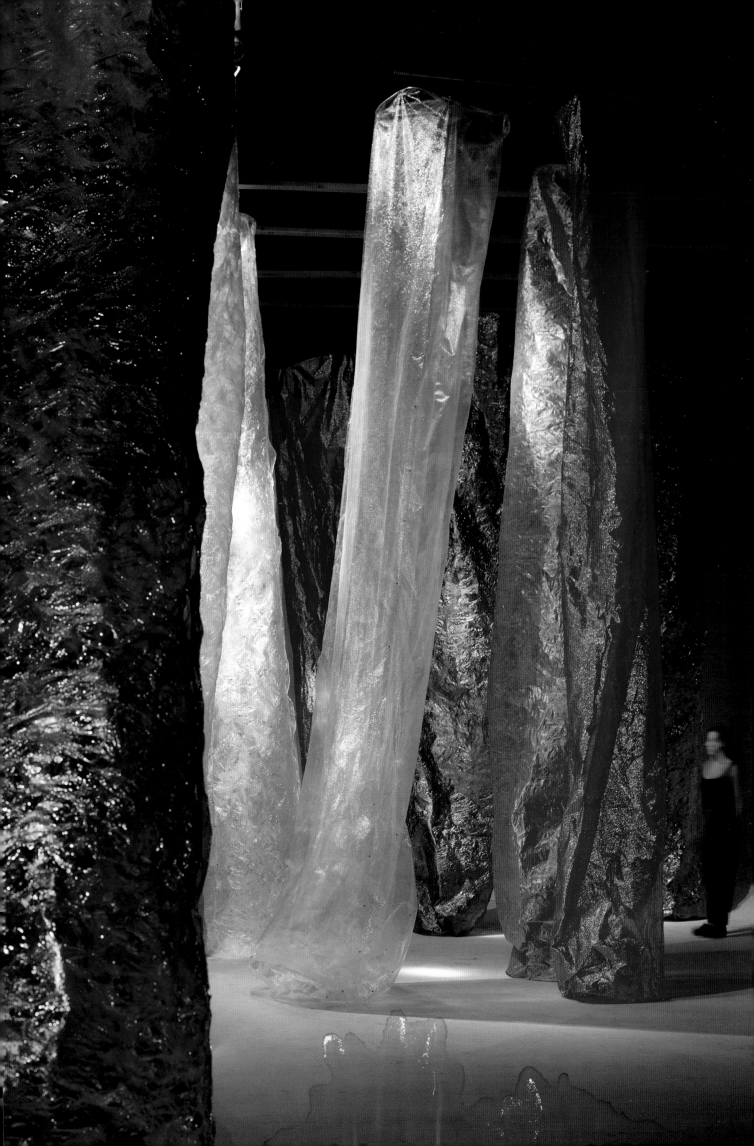

Thanks
Everybody!

Charley.
5·22·92